Learn to Paint
in Acrylics

with 50 Small Paintings

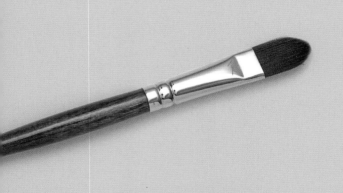

Learn to Paint
in Acrylics

with 50 Small Paintings

Mark Daniel Nelson

Quarry Books
100 Cummings Center, Suite 406L
Beverly, MA 01915

quarrybooks.com • www.craftside.net

Copyright © 2014 Quarto Inc.

First published in 2014 by
Fair Winds Press, an imprint of
The Quarto Group
100 Cummings Center
Suite 265-D, Beverly, MA 01915
T (978) 282-9590 F (978) 283-2742
QuartoKnows.com

Fair Winds Press titles are also available at
discount for retail, wholesale, promotional,
and bulk purchase. For details, contact the
Special Sales Manager by email at
specialsales@quarto.com or by mail at The
Quarto Group, Attn: Special Sales
Manager, 401 Second Avenue North, Suite
310, Minneapolis, MN 55401, USA.

ISBN: 978-1-63159-056-6

Digital edition published in 2014
eISBN: 978-1-62788-333-7

Library of Congress Cataloging-in-
Publication Data available

Conceived, designed, and produced by
Quarto Publishing plc
The Old Brewery, 6 Blundell Street
London N7 9BH

QUAR.AFSP

Senior editor: Victoria Lyle
Copy editor: Diana Craig
Proofreader: Ruth Patrick
Indexer: Helen Snaith
Designer: John Grain
Design assistant: Martina Calvio
Picture researcher: Sarah Bell
Illustrator: Cliff Mills
Photography: Phil Wilkins
Art director: Caroline Guest
Creative director: Moira Clinch
Publisher: Paul Carslake

Color separation in Hong Kong by
Cypress Colours (HK) Ltd
Printed in China

Contents

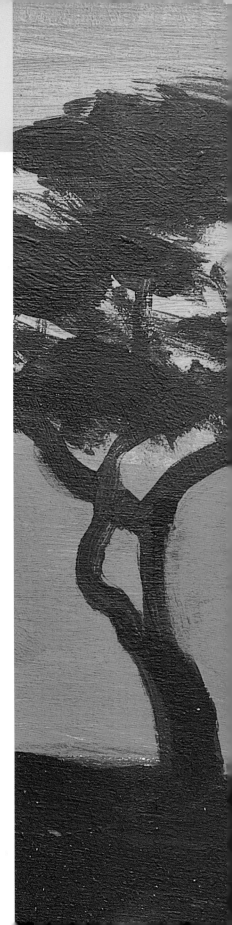

Welcome!

As an art student in my early twenties, I vividly remember an afternoon spent among the towering classics of art history at the National Gallery in Washington, D.C. The enormous Rothkos, Caravaggios, and Bierstadts overwhelmed me, as I was accustomed to seeing them only as tiny reproductions in my history books. Then something unexpected happened: I wandered into a cozy little room featuring a handful of small paintings. As I scanned the small works, one in particular caught my attention: a self-portrait by the French artist Henri Fantin-Latour.

How was it possible, I thought to myself, that in a museum filled with towering masterpieces, my favorite would be this humble little portrait?

Ever since that fateful day, I have had a deep affinity for small paintings. At their best, small paintings are direct and full of impact. Because there is less room for unnecessary details, small paintings often have an immediacy, clarity, and charm rarely found in large paintings.

When I was first approached with the idea of writing a book about learning to paint in acrylics using 50 small paintings, I jumped at the chance. In this book, I have done my best to convey my love of small, simple paintings and have designed the projects to be accessible for students of any ability. Most of the projects in this book will take less than an hour to execute and they all cover fundamentals that will help you to grow in your skill with acrylic paint. My hope is that you will find these 50 projects to be engaging and that you will see the value in learning to paint in acrylics, one small painting at a time.

Mark Daniel Nelson

"Great things are done by a series of small things brought together." **Vincent van Gogh**

Project gallery

The project gallery showcases the 50 paintings in the book.

Take a walk around, select the one you would like to paint, then turn to the relevant page of instructions to create your chosen piece.

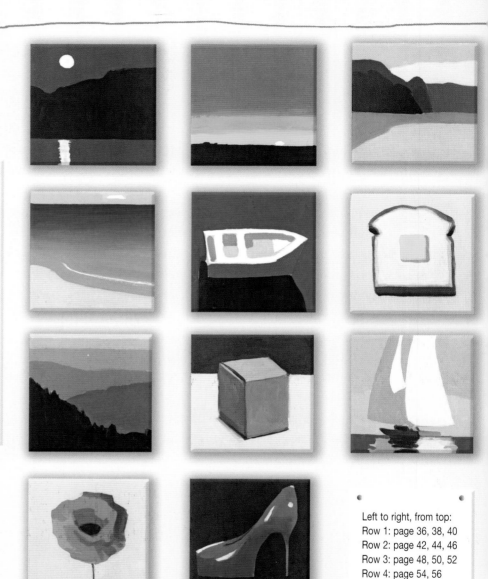

Left to right, from top:
Row 1: page 36, 38, 40
Row 2: page 42, 44, 46
Row 3: page 48, 50, 52
Row 4: page 54, 56

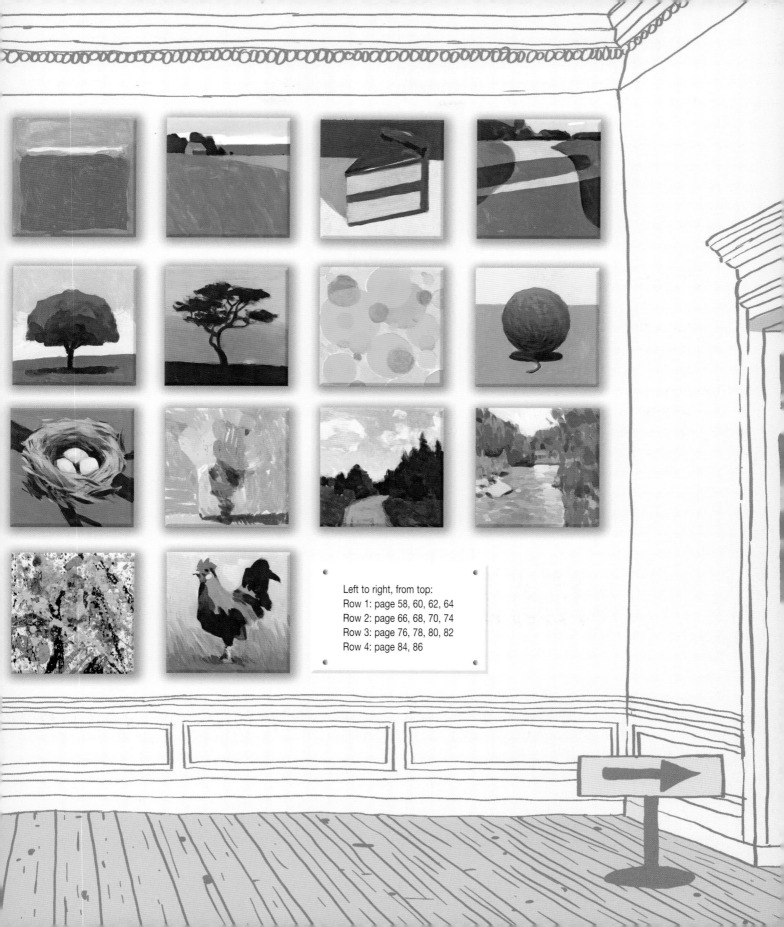

Left to right, from top:
Row 1: page 58, 60, 62, 64
Row 2: page 66, 68, 70, 74
Row 3: page 76, 78, 80, 82
Row 4: page 84, 86

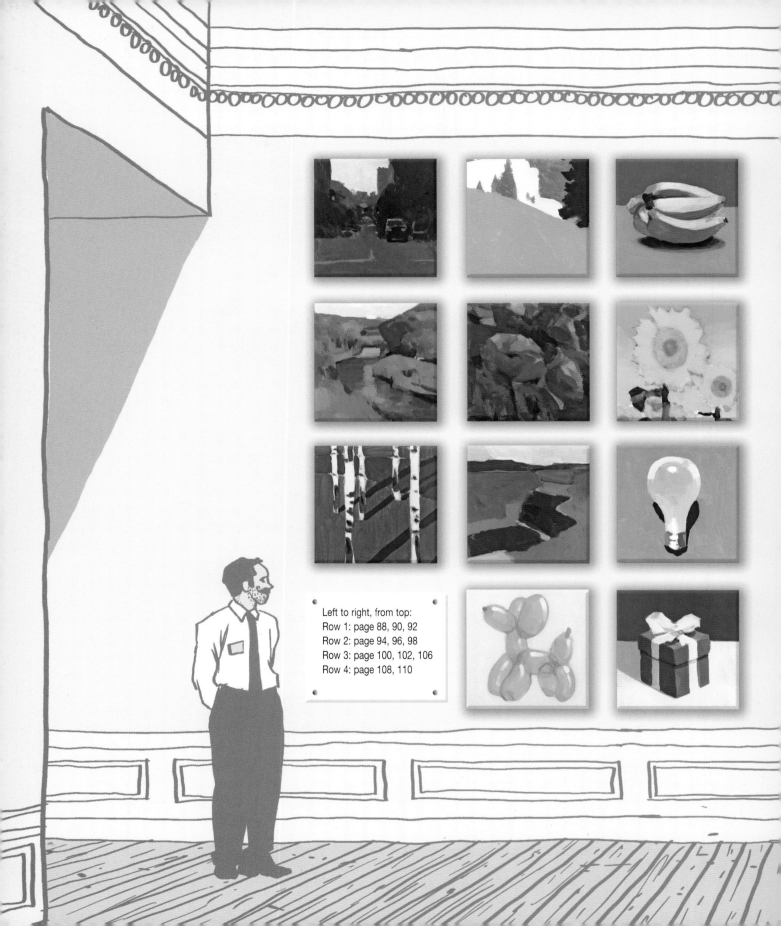

Left to right, from top:

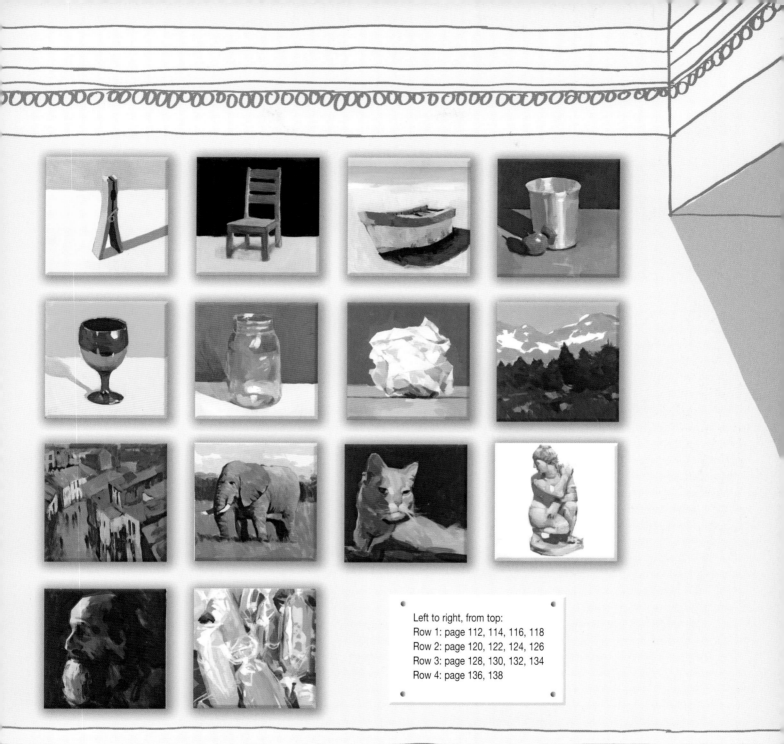

Left to right, from top:
Row 1: page 112, 114, 116, 118
Row 2: page 120, 122, 124, 126
Row 3: page 128, 130, 132, 134
Row 4: page 136, 138

To the projects ▶

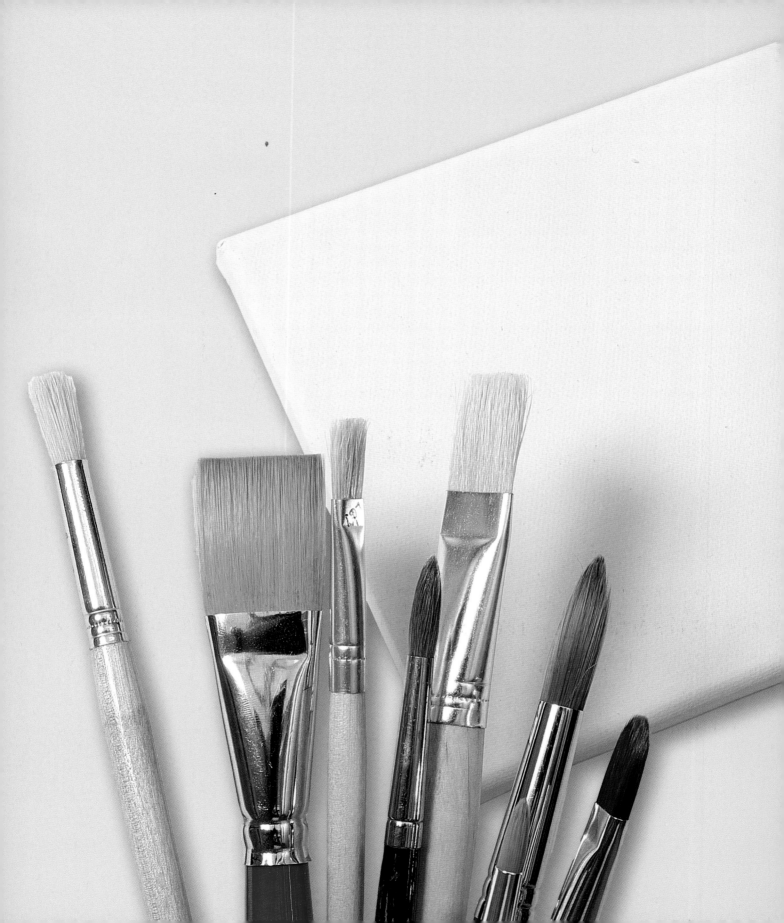

Chapter 1

Introduction to materials and techniques

Before getting started on the 50 paintings, it is important to explore the options for materials as well as to consider essential principles about color and design. This chapter will introduce you to the basics of acrylic paint, brushes, surfaces, and the equipment you will need to complete the projects illustrated in this book.

Choosing a surface

For the examples in this book, I applied acrylic gesso to 5 x 5 in. (12 x 12 cm) panels of ¾-in. (20-mm) thick MDF (medium density fiberboard).

The most popular choice for a painting surface when using acrylics is a pre-stretched, acrylic primed canvas purchased from an art supply store. There are, however, many alternatives to the traditional approach of painting on a prepared canvas. Acrylic paint manufacturers have recently introduced a wide array of products for use in preparing surfaces such as glass, metal, and cloth.

	TYPES	PROS	CONS	PREPARATION
Paper	Canvas paper Multimedia paper Acrylic painting pads	Less expensive than canvas Readily available Smooth surface Easy to cut Portable	Not as durable as canvas Warps easily	Paint directly on pad Add gesso or other ground
Canvas	Pre-stretched primed canvas Canvas mounted to a board Unmounted canvas rolls Unprimed canvas rolls	Readily available at most art stores Textured surface Portable Bouncy surface	Most expensive option Not durable if stretched Difficult to cut	Stretch Add gesso
MDF/Masonite/ Wood panel	⅛-in. (3-mm) thick Masonite ¼-in. (6-mm) thick hardboard ⅝-in. (15-mm), ¾-in. (20-mm), or 1-in. (25-mm) thick MDF Birch plywood Poplar or basswood panel	Extremely durable Inexpensive Rigid surface	Requires treatment Heavy Difficult to cut Can warp when wet	Add gesso

For the purposes of this book, I suggest preparing your own surfaces. This approach is much less expensive than buying a large number of canvases and it will allow you to experiment without fear of wasting money if something does not work out the way you had hoped.

If you decide to prepare your own surface for painting, there are many options available. The simplest involves applying acrylic gesso to your surface (there is also an oil-based gesso, so be sure the label says "acrylic gesso"). More expensive gesso will cover the surface area more quickly; less expensive gesso will require multiple layers.

While it is possible to paint directly onto paper, you will find that doing so leads to warping and buckling if the paper is not mounted to a stable surface. If you like the texture of paper, but want the rigidity of surface that a board provides, you can mount paper or canvas to a hard surface using ph-neutral glue. Mounting the paper will make your painting surface more durable but will also add weight, which may be a consideration if you need to transport the paintings when they are finished.

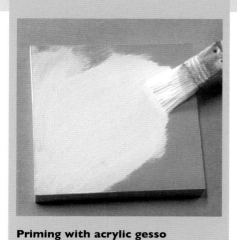

Priming with acrylic gesso
To prime a panel with acrylic gesso, simply spread the gesso evenly with a 1 in. (25 mm) brush. Wait about 10 minutes and add a second coat. The surface will be ready to paint when dry to the touch (after about 15 minutes).

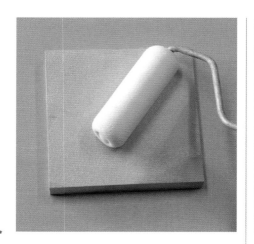

Mounting canvas or paper to a panel
1 To mount canvas or paper on a panel, begin by applying ph-neutral glue to the entire surface of the panel using a small foam paint roller. This will adhere the paper or canvas to the panel as well as protect them from any acidity that may be present in the panel material.

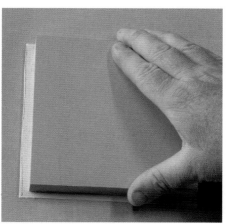

2 Press the panel firmly on top of a piece of primed canvas or paper (the glue will stick to the unprimed side).

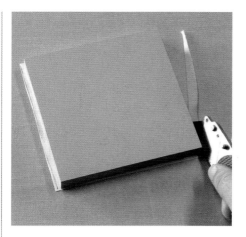

3 Trim the edges of the canvas or paper with an X-acto knife and allow to dry for 1 hour before painting.

Acrylic paint

There are myriad formulations of acrylic paints available to the beginner and the advanced painter alike.

Before considering the details of the different products, it is helpful to understand that all acrylic paints consist of a combination of pigment (which usually begins in powder form) and binder (which holds the pigment together). The binding agent in acrylic paint is polymer-based (i.e. plastic, as opposed to the oil used to bind oil paints). The difference in price and quality from one brand to another is based on the ratio of pigment to binder in the paint. The advantage of acrylic paint over other mediums is its rapid drying time. One significant disadvantage to using acrylics, however, is that the acrylic binder cannot hold as much pigment as paint with oil-based binders. This results in more transparent paints, better suited to layering and glazing than to thick, opaque application.

You can buy acrylic paint in tubes, pots, bottles, markers, and spray cans—the packaging will often be dependent on the viscosity.

HEAVY BODY VS. SOFT BODY ACRYLICS

Most acrylic paint brands offer "heavy body" and "soft body" (also referred to as "fluid") versions of their paints. It may seem a bit counterintuitive, but soft body paints are slightly more opaque due to the fact that less binder is used in the formulation.

Acrylic paint comes in a wide range of viscosities to suit different artist's preferences and needs. Soft-body paint (far left) is for thin applications, whereas heavy body paint (left) is for thick applications, such as impasto.

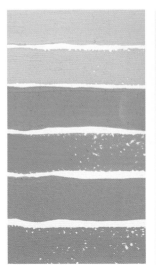
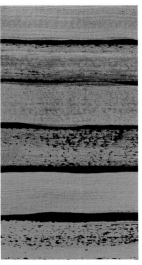

Soft body
Cadmium Yellow Light

Heavy body
Cadmium Yellow Light

Soft body
Brilliant Yellow Green

Heavy body
Brilliant Yellow Green

Soft body
Light Blue Permanent

Heavy body
Light Blue Permanent

The top stripe of each color was painted using soft body acrylic without diluting with water or medium. The bottom stripe of each color was painted using heavy body acrylics without water or medium. Notice that while neither is fully opaque even at full strength, the soft body acrylics are slightly better at covering evenly.

"STUDENT" VS. "PROFESSIONAL" PAINTS

Student-grade paints are often cheaper because they contain less pigment. These paints can be useful if you are just starting out in acrylic paint. Be aware that student- (or "craft-") grade paints are rather transparent and that you will have a difficult time painting light colors over dark colors (yellow over black, for example). Higher-grade paints are more expensive because they contain more pigment, making them considerably more opaque.

Student-grade paints are less opaque than the professional-grade versions. This can be seen particularly clearly with Cadmium Yellow Light and Cadmium Red Medium. However, the effect is less pronounced with Mars Black, Ultramarine Blue, and Unbleached Titanium

Burnt Sienna
(student)

Burnt Sienna
(professional)

Yellow Ochre
(student)

Yellow Ochre
(professional)

Ultramarine Blue
(student)

Ultramarine Blue
(professional)

Unbleached Titanium
(student)

Unbleached Titanium
(professional)

Titanium White
(student)

Titanium White
(professional)

Cadmium Yellow Light
(student)

Cadmium Yellow Light
(professional)

Mars Black
(student)

Mars Black
(professional)

Cadmium Red Medium
(student)

Cadmium Red Medium
(professional)

"HUES" AND "MIXTURES" VS. "PURE" PIGMENTS

Another way to reduce the price of some of the most expensive paints (cadmiums, for example) is to make a mixture that approximates the more expensive color. These are referred to as "hue" or "mixture" on the label.

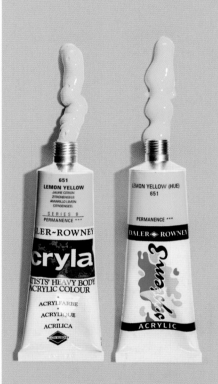

Lemon Yellow and Lemon Yellow (Hue) look the same, but the hue is an approximation of the pure color made with less expensive pigments.

Acrylic paint continued

BASIC PALETTE
If you are on a budget or are just starting out with acrylics and aren't ready to make a large investment in materials, here is a suggested group of colors:

Beginner
If you are new to acrylics and don't want to spend too much money on your first set of paints, try the student-grade versions of the colors on this list.

Intermediate
If you are ready to make an investment in a higher-grade selection of colors, try the standard versions of these colors (not student grade).

Advanced
For a professional-grade selection of colors, add the "pure" versions of the cadmium colors as well as a few more blues and a violet.

Titanium White

Alizarin Crimson

Primary Yellow

Ultramarine Blue

Mars Black

Unbleached Titanium

Burnt Sienna

Yellow Ochre

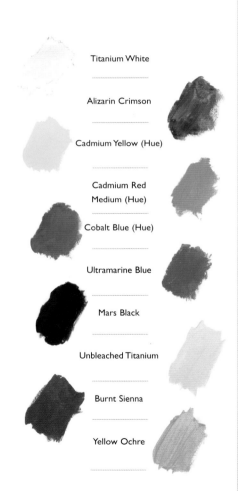

Titanium White

Alizarin Crimson

Cadmium Yellow (Hue)

Cadmium Red Medium (Hue)

Cobalt Blue (Hue)

Ultramarine Blue

Mars Black

Unbleached Titanium

Burnt Sienna

Yellow Ochre

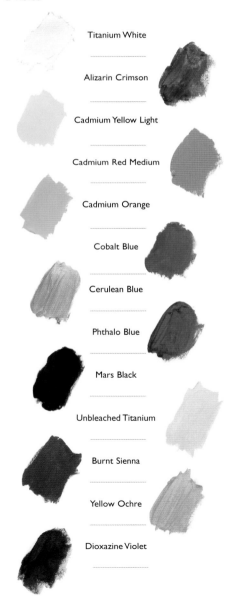

Titanium White

Alizarin Crimson

Cadmium Yellow Light

Cadmium Red Medium

Cadmium Orange

Cobalt Blue

Cerulean Blue

Phthalo Blue

Mars Black

Unbleached Titanium

Burnt Sienna

Yellow Ochre

Dioxazine Violet

MEDIUMS AND ADDITIVES

Acrylic paint is pigment suspended in a binder or "medium."

It is recommended that you use a medium rather than water to thin your paint to a usable consistency. This is because adding water to the paint will not only thin the pigment, it will also thin the binder. This will compromise the paint's ability to stick to initial layers, especially after they have dried. Thinning with an acrylic medium will work better than thinning with water because it is pure binder, which will adhere to the previous layers better than water.

The market for acrylic mediums is vast and can be overwhelming to the novice. For the projects in this book, I used matte acrylic painting medium to thin the paint. However, here are some of the other options available:

Thickeners: Gel mediums make the paint very thick. If you like textured brush strokes, try mixing a gel medium into your paint.

Matte, satin, or gloss mediums: If the sheen of the finished painting is important to you, there are many mediums to consider. Matte mediums are dull, satin mediums have a little reflectivity, and gloss mediums are very shiny. My own preference is for the matte mediums since they unify the surface without creating distracting reflections.

Matte

Satin

Gloss

Open mediums/retarders: If your paint is drying faster than you are comfortable with, retarding mediums will slow the drying time, allowing you to work at a slower pace.

Glazing mediums: A thin, slippery medium ideal for glazing layers of pigment. This medium will reduce the pigment load considerably.

Brushes

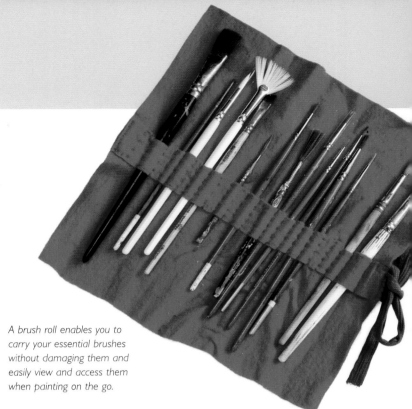

Trying to choose the "right" brush from the seemingly countless offerings available at the art supply store (or online supplier) can overwhelm even the most seasoned painter.

The variety of material, shape, size, and price can make choosing your brushes quite difficult. Even though there is a handful of objective characteristics to keep in mind when deciding on your brushes, in the end you should choose brushes that suit your personal taste. How the brush feels in your hand, the weight and balance of the brush, the length of the handle, and even the price of the brush are issues to consider.

A brush roll enables you to carry your essential brushes without damaging them and easily view and access them when painting on the go.

BRUSH SHAPE

These are the basic shapes of brushes, and they are all useful. You can never have too many brushes!

Bright (1): Short, flat profile. Best for making short, rectangular strokes.
Flat (2): Same shape as bright, but has longer bristles and can hold more paint.
Filbert (3): Similar to flat, but has a rounded tip. Excellent all-purpose brush.
Liner (4): Very thin and long. Ideal for fine-detail work.
Round (5): Can be used to make thick or thin strokes. Excellent all-purpose brush.
Mop (6): Large brush best for filling large areas quickly.
Palette knife (7): Good for applying thick, blunt strokes or very fine lines with the edge.
Egbert (8): Long-bristle filbert brush. Good for spatter effects. Difficult to control, however.
Fan (9): Good for painting textured lines (like grass or hair).

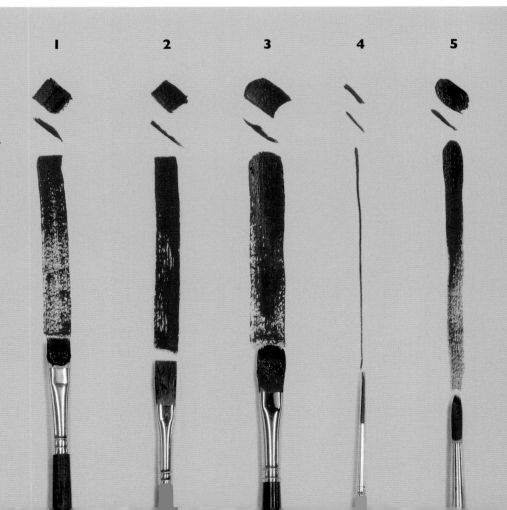

1 2 3 4 5

Stiffness vs. softness

Feel the bristles of the brush. If they are stiff, the brush will be more useful for applying thick, impasto strokes. A softer brush will absorb more paint and is ideal for applying layers of thin paint.

Natural vs. synthetic bristles

Natural (fur taken from an animal) bristle brushes are more expensive than synthetic (manufactured) bristle brushes. Acrylic paint can damage brushes faster than other mediums due to the need to clean the brushes more often, so more durable synthetic bristles are generally the better option.

Brush size

Large brushes are useful when covering large areas; small brushes are better for fine-detail work. A good medium-sized brush will often replace the need for either large or small brushes.

Student vs. professional grade

Most art supply stores carry different grades of paintbrush. "Student" brushes are less expensive but also less durable. "Professional" brushes will last many years with proper cleaning and care.

Price

It's best to buy a small number of quality brushes and take good care of them rather than buy many low-quality brushes, which will only last a few projects each. If you are just starting out with painting, inexpensive materials are tempting, but you will end up replacing them more often, negating the savings.

PROPER CARE OF BRUSHES

Use a water jar with a grate inside to clean your brush completely when you are waiting for a layer to dry or taking a break. Acrylic paint will dry very quickly on a brush that has not been cleaned and the brush will be ruined for future use. Also, do not leave the brush sitting in water for long periods of time as this will damage the brush shape and possibly loosen the ferrule from the shaft. When you have finished painting for the day, wash your brush with brush soap and remove any pigment left in the bristles. If the brush has lost its shape, apply a generous amount of brush restorer (available at art supply stores) and reshape the brush until the next painting session.

Acrylics can and will destroy brushes permanently if paint is left to dry on them, so make sure you clean them thoroughly with water.

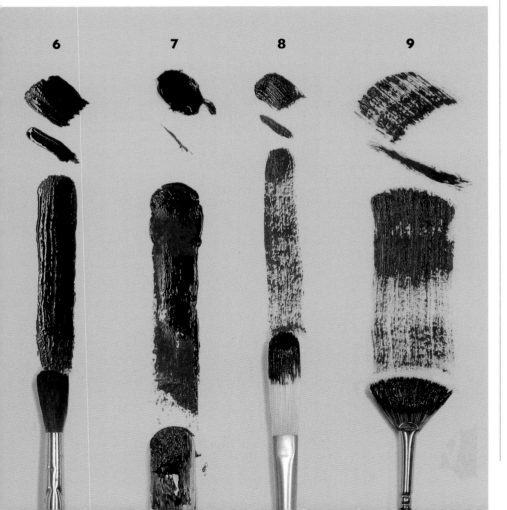

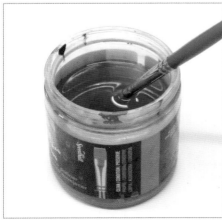

Palettes

Perhaps the most useful feature of acrylic paint is its ability to dry to a hard, durable finish in a matter of minutes. This can be helpful in most cases, but the fast drying time also creates a problem—the paint you've squeezed out on your palette often dries before you can use it. One solution to this problem is to use a wet pad or sponge as a surface for mixing and storing your paint.

My favorite palette is the Acryl-a-Miser™ palette system (below). It comes with many compartments for holding paint and the lid is very easy to open and close.

CHOOSING YOUR PALETTE

Palettes come in a wide variety of materials, shapes, and sizes to suit every artist's preference. You can buy one specifically manufactured for use with acrylic paint, or you can simply reuse an old dinner plate or recycle food packaging (such as plastic yogurt lids) as a palette.

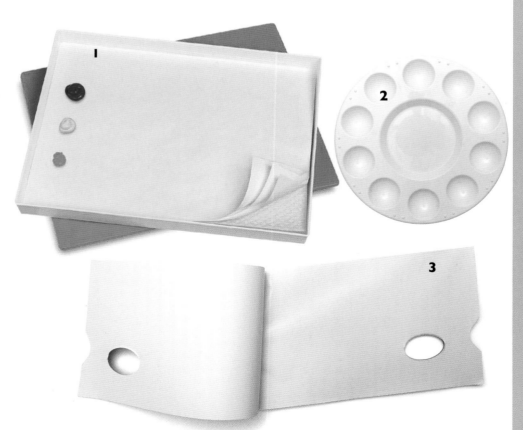

Plastic palette with lid and sponge (1)

A "palette in a box" with a lid and sponge to keep paints from drying out.

Pros: Easy to keep paint wet for long periods of time; lightweight; easy to clean.

Cons: Lid can be difficult to remove on some palettes; buying sponges/wet pads can be expensive over time.

Small, circular palette (2)

A plastic disk with areas for storing and mixing paint.

Pros: Lightweight; takes up very little space; colors stay clean thanks to individual "bowls".

Cons: Very small mixing area; cleanup can be difficult.

Palette paper (3)

A pad made of pages of coated paper.

Pros: Inexpensive; easy cleanup (simply throw used palette away); lightweight; easy to transport.

Cons: Paper has a tendency to buckle after extended use; cannot store colors long-term; some paint may be wasted when palette is thrown away

LAYING OUT YOUR PALETTE

There are many approaches to organizing the layout of your palette. You may choose to follow the color wheel, you may want to organize by values (white and yellow on one side, purple, brown, and black on the other), or you may have your own ideas about the order you would like your colors to follow. Squeeze the paints in thin lines rather than piles to keep each color clean as you dip into it.

Here is the way I lay out my palette:

My own approach to laying out colors on a palette is quite simple: I place warm, non-earth tones on the left, cool blues and purple in the middle, and earth tones on the right. Titanium White on the left, then Cadmium Yellow Light, Cadmium Orange, Cadmium Red Medium, Alizarin Crimson, Dioxazine Purple, Ultramarine Blue, Yellow Ochre, Burnt Sienna, and Mars Black. This arrangement has evolved over the years to help keep my thinking about color organized.

Warm

Cool

IMPROVISED PALETTE

To make your own palette, place 3–4 kitchen sponges underneath and on either side of an ice cube tray inside a small plastic storage bin. Pour enough water over the sponges so that they are damp but there is no standing water at the bottom of the container. Fill the ice cube tray with your colors. Spray the palette periodically with water to keep the paint from drying out and cover the container with a lid when not in use. One drawback is that the sponges and paint can become moldy if left closed for too long. A tablespoon of ammonia applied to one of the sponges will remedy this.

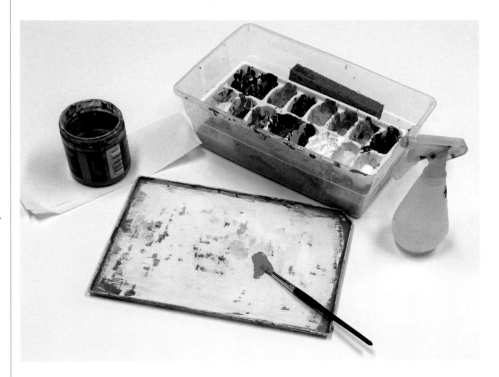

This homemade palette is very inexpensive and with minimal attention the paint can be kept wet for weeks and even months at a time.

Color and value

The relationship between color and value is perhaps the most important (and often the most elusive) concept for the painter to grasp. To put it simply, some colors are light, some are dark, and some sit between light and dark.

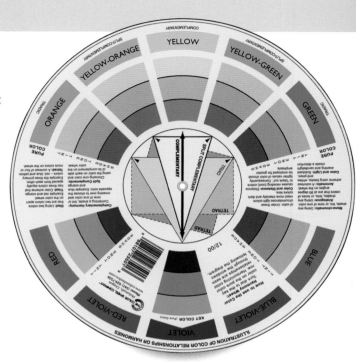

COLOR

The color wheel is a device artists have used for hundreds of years to help better organize the colors they use in paintings. Although nature contains infinite variations of color, it is helpful to limit the range of colors you use to keep your paintings unified and harmonious. The practice of using limited groups of color is often referred to as a "color scheme." Here are a few of the most common color schemes:

Color wheel

The color wheel is a helpful tool for choosing groups of colors as you work.

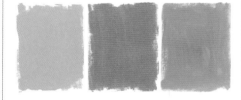

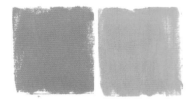

Analogous

Using colors close to one another on the color wheel: limiting the color range to include only blue-green, green, and yellow-green, for example.

Complementary

Using colors at opposite sides of the color wheel: blue and orange, for example.

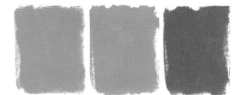

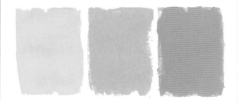

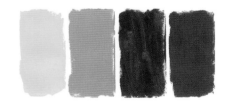

Split-complementary

Similar to complementary except instead of using opposite colors, use two colors next to one of the opposing colors. Red-orange with blue and green, for example.

Triad

A triad color scheme utilizes three colors of equal distance from one another on the color wheel. Red, blue, and yellow would make up a "primary triad." Orange, green, and purple would make up a "secondary triad."

Tetrad

A tetrad is a rather complicated color scheme to manage. In it, you choose two colors from one side of the color wheel and combine those colors with two from the opposite side, making a square or rectangle on the color wheel.

VALUE

If you learned how to draw using only a pencil or pen, then you are accustomed to thinking in terms of value: light and dark. When speaking about color, the term "value" refers to the relative lightness or darkness of a color. For example, yellow has a light value, purple has a dark value. A useful technique for comparing the values of different colors is to squint your eyes when looking at them. If the boundary between the colors disappears, they have the same value. Identifying the value of a color is essential when mixing your paint, particularly when it is necessary to simplify a complicated scene. By reducing the number of values in a painting, you will make a painting that is more cohesive and harmonious.

Understanding and using value

Even though our eyes can see (and we are able to assign a name to) different colors, viewing them in black and white shows that they have the same value, as the sequence to the right demonstrates.

The colors printed here are easily identified as orange, blue, and pink

When the color is removed from the shapes, it becomes clear that there are three nearly identical values.

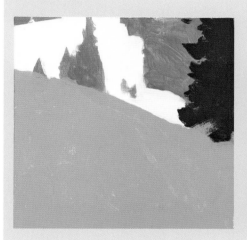

The painting above is an example of this principle. When seen in full color, the blue shadow on the snow and the green color of the trees appear as separate areas with different colors.

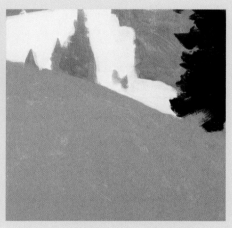

When seen in black and white, however, it is clear that the values of the foreground snow and the distant trees are almost identical. By "joining" the values, the painting becomes more unified.

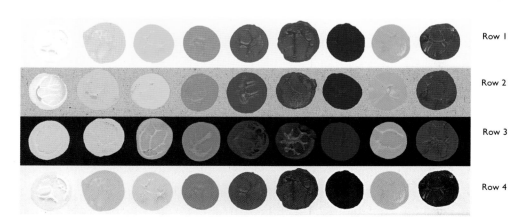

Row 1

Row 2

Row 3

Row 4

Converting hues to black and white reveals their values (row 4). It's often easier to judge the values of different hues against a mid-value ground (row 2) rather than a pale (row 1) or dark-value one (row 3).

Basic design principles

When creating a painting, it is common for the artist to focus so much attention on rendering an object or a scene that the idea of designing a cohesive composition never enters his or her mind. In order to make pleasing, cohesive arrangements, it is important to pay attention to a few basic principles when designing your paintings.

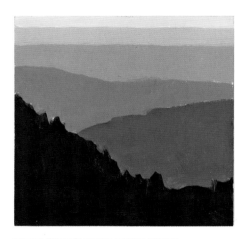

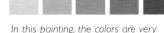

In this painting, the colors are very similar, as are the shapes.

Here, the yellow and orange of the sunflowers are unified; the colors yellow, orange, green, and blue as a group are harmonious.

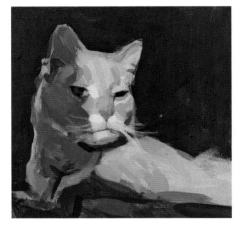

The cat is brought into dramatic relief by the nearly black background contrasting powerfully with the light on the cat's body and face.

UNITY

To create cohesive, coherent paintings, unify the elements with shared attributes. By using similar colors, shapes, and even brushstrokes, all of the parts of your painting will work together to create a unified whole.

HARMONY

Harmony is a very similar concept to unity, with the exception that you are looking for elements that complement (rather than match) one another. Choose colors that enhance one another as a group.

CONTRAST

If your goal is to create dramatic compositions, this can be achieved by exaggerating the contrast between either the values or the colors. For dramatic tonal contrast, use light against dark. For vibrant color contrast, use colors from opposite sides of the color wheel.

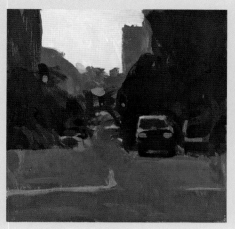

FOCAL POINT

Perhaps the most important thing to consider when making a painting is to have a "focal point," which refers to the most important piece of the painting. All other parts of the painting are arranged to subordinate the focal point.

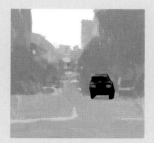

In this painting, the car on the right is the focal point.

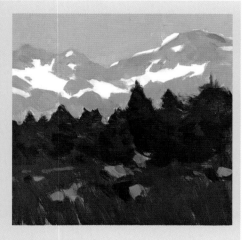

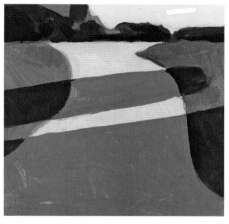

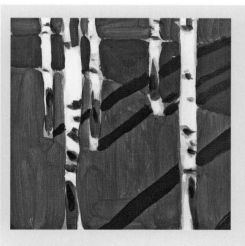

BALANCE

Use pleasing relationships and proportions to create a sense of calm balance. Balance in composition can be either symmetrical (equal) or asymmetrical (unequal). Symmetrical balance means each part is equally weighted with the center of the canvas. Asymmetrical balance involves arranging the parts in a less rigid, more rhythmic manner.

DOMINANCE

One of the most common examples of using the principle of dominance is in choosing a placement for the horizon line. To place it exactly in the middle of your canvas divides the painting into equal parts, which usually creates an uncomfortable tension. Move the horizon line up to allow the land to dominate, or down to allow the sky to dominate. This principle also applies to color (dominant hue), value (dominant key), shape (dominant object), etc.

REPETITION

To move the viewer's eye through the painting, simply repeat similar shapes, colors, etc. Since most people read from left to right, it is helpful to place the object you are repeating to the left of the composition and repeat it as you move to the right.

Here, the mountain occupies a third of the image. The foreground and trees are half the painting.

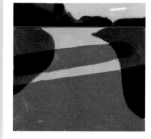

With the horizon line near the top of the painting, the road area becomes more dominant.

Here, the shape of the tree is repeated, as are the knots in the trees and the tree shadows.

Transferring your drawing

If you are unaccustomed to sketching the initial outlines of your painting with a brush (a method used in nearly every project in this book), you may prefer to transfer the image directly to your canvas/panel/paper before starting with the brush. There are three different ways of doing this: using graphite, using a grid system, or using a projector.

	Graphite	**Grid system**	**Projector**
PROS	Easy to do Accurate	Easy to get accurate image without damaging the canvas/panel	Easy to achieve accuracy of line and placement of image on canvas
CONS	May destroy original image Leaves a slight indentation in the paper/panel.	Time-consuming Destroys original image	Projection equipment can be expensive and requires some expertise to operate

Using graphite

1 Apply graphite to the back of your pencil drawing. Alternatively, you can buy graphite paper from a store and sandwich it between your drawing and your support.

2 Place the drawing right-side up on your support and trace over the linework—the graphite will transfer onto your support, leaving an outline.

1 2

Using a grid system

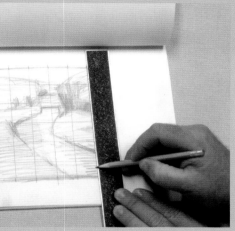 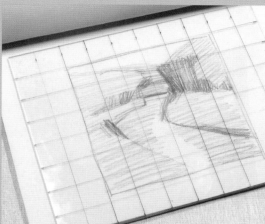 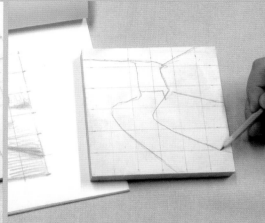

1 Lightly draw a grid over your source image, then draw a grid with the same number of squares on your support.

2 Alternatively, if you don't want to draw on your original sketch or photograph, you can draw a grid with black marker on a piece of glass and place that over your source image.

3 Carefully copy each square to correspond with the same square on the original image.

Using a projector

Use an opaque, transparent, or digital projector to project your drawing onto the canvas/panel/paper and lightly trace the linework. Make sure your painting support is at a perfectly perpendicular 90° angle to avoid a skewed or distorted projection.

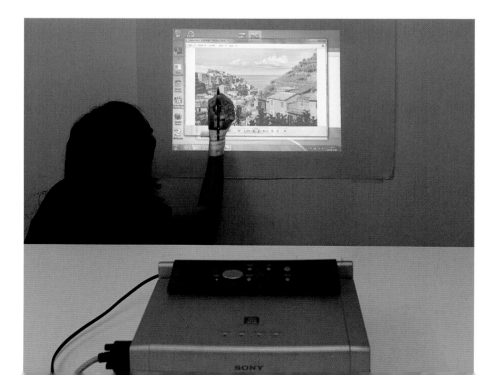

Displaying your work

As you progress through the projects in this book, you may notice that the finished paintings are designed to hang together in groups.

By keeping the size of the paintings consistent, there is a built-in similarity that will coordinate the paintings when they are displayed. Spend some time exploring unconventional relationships between the paintings and arranging them in interesting and unexpected combinations. Below are some suggestions for organizing the display of your work as well as some ideas for attaching them to the wall.

FRAMING

If you choose to work on a surface (such as paper or unstretched canvas) which cannot be displayed without framing, you'll need to consider either using a mat, a frame, or some combination of the two.

Mats

Paintings on paper need to be separated from the glass by an airspace. The mat provides this, and also enlarges the clear space around the artwork. It's common practice to make the bottom edge ½ in. (12 mm) wider than the top and sides to correct an optical illusion when all are the same. Make sure to use acid-free boards. Choose pale, neutral shades; ivory is classic. Avoid unusual colors that may overpower the painting.

Frames

If you choose to execute your paintings on a three-dimensional surface (such as a stretched canvas or MDF panel) you may want to display the artwork in a conventional frame. Most art-supply stores offer at least a limited selection of designs to choose from and some offer custom framing services. Generally speaking, small, simple paintings will look best in simple frames. Ornate and overly decorative frames are likely to distract from the painting and often cost more, as well. If you do not live near an art-supply store or a specialty frame shop, many online suppliers offer a wide range of frame designs to choose from. Most suppliers will offer a substantial discount if you order multiple frames at the same time.

HANGING THEMES

While it is perfectly acceptable to hang your paintings in a random order, you may also want to arrange the paintings according to specific themes. A few suggestions—color, shape, and subject—are shown, right.

A thin mat will give your painting a sleek, modern look.

A medium-sized mat will not distract from the painting.

A large mat with offset center will focus attention on your painting.

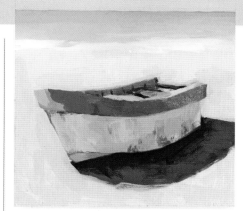

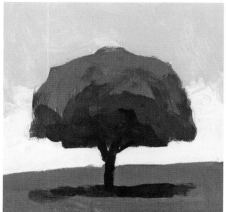

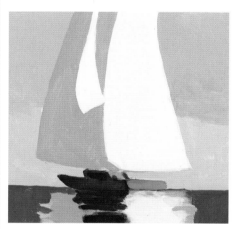

Color

Look for similar color schemes to get a unified group of paintings. You may want to arrange a group of red objects, or use the analogous blue, green, and yellow color scheme shown here.

Shape

Find repeating/similar shapes for unexpected groupings. Look for symmetrical objects with round shapes or perhaps a grouping of square shapes.

Subject

Group the paintings by subject. Boats, trees, roads, objects, and animals are a few of the repeating themes in this book.

Displaying your work continued

HANGING CONFIGURATIONS

Because the paintings are presented as a group, it is helpful to arrange the paintings according to a consistent pattern.

Hanging the work without frames will present your paintings in a more informal manner.

Line

Simply hang the paintings at the same height with equal distance between each painting. This has the benefit of showing the work in a progression. It can be difficult to get all of the paintings to align properly so stand back to check this as you hang them.

Grid

Hang the paintings in grids of 2 x 2, 3 x 3, 4 x 4, etc. It is easy to show a large group of paintings in a small space if you hang them as a grid. Because the paintings from this book are quite small, it is possible to hang a large number of them in a small space by using a grid. Make accurate measurements for the hooks/nails to ensure the paintings line up vertically and horizontally.

Random

Hanging the paintings in a haphazard, random arrangement will give the group a less formal and perhaps more "creative" appearance. This will work especially well in a casual environment such as a coffee house or your own studio.

ATTACHING THE PAINTINGS TO THE WALL

Once you have decided on your hanging theme and configuration, there are various hardware options for attaching your framed artwork, panel, or canvas to the wall.

1 Canvas and nail

A simple option for hanging is to paint all of your projects on small stretched canvases and hang the stretcher bar on a nail.

2 Keyhole

If you are painting on wood or MDF and own a router table, you can quickly cut a keyhole in the back of your panels. Set up the table so that all of the cuts are identical and place on equally spaced nails.

3 D-ring

If you are working on MDF, wood, or plywood, screw a D-ring into the back of the panel and hang on a nail.

4 Wire

Attach two D-rings and wrap picture-hanging wire between them. Hang on a nail or hook.

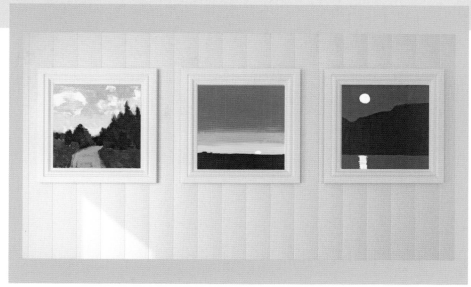

Hanging your paintings in a plain frame will not detract from the artwork.

1

2

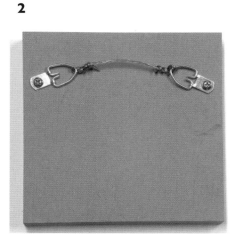

3

4

Chapter 2

Getting to know acrylics

In this chapter, you will be introduced to the primary techniques needed to paint in acrylics through a series of progressively challenging projects. You will start with basic paint application exercises and slowly add new skills with each project. By the end of this chapter, you will have acquired the fundamentals necessary for painting in acrylics.

1 | Basic paint application:
Moonrise

Materials

- White paper, canvas, or gessoed panel
- #8 round brush
- Palette
- Water
- Acrylic painting medium

Color palette

- Titanium White
- Mars Black

Try these

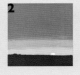
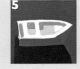
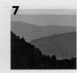
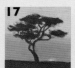

For the introductory project of this book, you will be painting a very simple scene using only Titanium White and Mars Black. If you have never painted in acrylics before, now is the perfect time to explore the consistency and mixing properties of the medium. Practice mixing different quantities of the colors on your palette and see how they influence one another. Experiment with the amount of pressure you exert on the brush when you apply the paint. Also, pay attention to how quickly the paint dries and observe the basic working qualities of the medium.

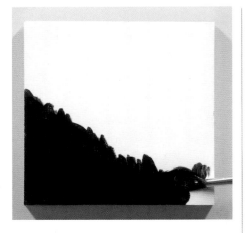

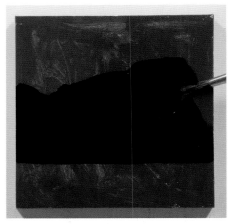

1 On your palette, practice mixing Titanium White and Mars Black to create a gray color. Mars Black is slightly more opaque than Titanium White so mixing equal amounts of the colors will result in a gray that is dark. When you have mixed a dark gray, cover the entire paper, canvas, or panel with this mixture.

2 Wait 5 minutes for the initial layer to dry. Meanwhile, clean and dry your brush. Now use Mars Black to paint the silhouette of a mountain in the distance. Make this layer as opaque as possible and do your best to paint sharp, crisp edges along the bottom and top of the silhouette.

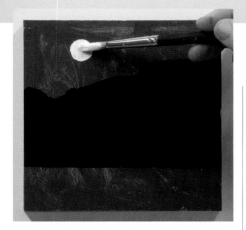

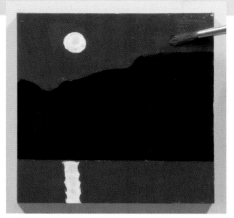

5 Mix a gray that is as close as possible to the color you applied in step 1. Use this to fill in the sky and water with an opaque layer of paint. Use this same color to clean up any stray brushstrokes that remain around the moon and the mountain.

3 To paint the moon, apply a small circle of Titanium White just above the mountain. You may need to apply two or three layers before the paint becomes completely opaque. Allow a few minutes between each layer for the paint to dry before adding the next layer.

If you feel as if you need more practice mixing and applying paint, try painting another version of this scene with the moon in a different part of the sky.

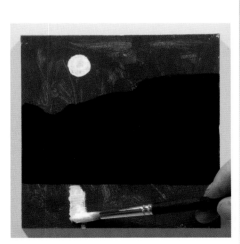

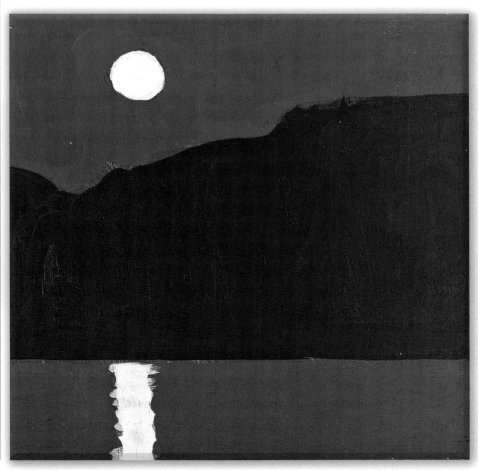

4 Next, paint the reflection of the moon on the water using Titanium White. Be sure to place the reflection directly beneath the moon. To create the illusion of ripples on the water, apply the paint using short, horizontal strokes.

2 | Applying colored paint:
Simple sunset

Most people appreciate the beauty of a dramatic sunset, so it's not surprising that artists the world over have been making sunset paintings for hundreds of years. For this simple project, you will not need to mix any colors; you will simply use the colors at full strength right out of the tube. Cadmium Yellow Light will be first because it is the most transparent. Cadmium Orange and Cadmium Red will follow and you will finish with Mars Black and Titanium White.

Materials

- White paper, canvas, or gessoed panel
- #8 round brush
- Palette
- Water
- Acrylic painting medium

Color palette

- Cadmium Yellow Light
- Cadmium Orange
- Cadmium Red Medium
- Mars Black
- Titanium White

Try these

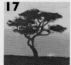
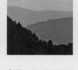

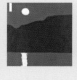

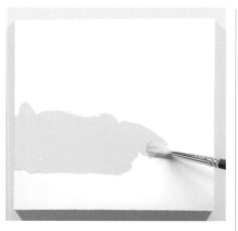

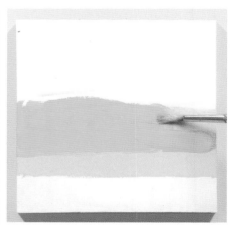

1 Apply a wide horizontal strip of full-strength Cadmium Yellow Light to your paper, canvas, or panel. You will be applying the next colors over the top of this color so there is no need to worry about the exact placement of the strip. Just be sure to cover an area similar to that shown in the photo.

2 When the painted yellow strip has dried after a few minutes, apply a similar band of full-strength Cadmium Orange above. Use horizontal strokes to create the illusion of bands of clouds layered on top of one another.

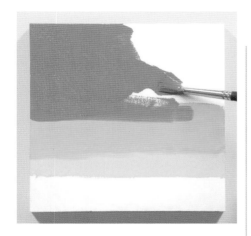

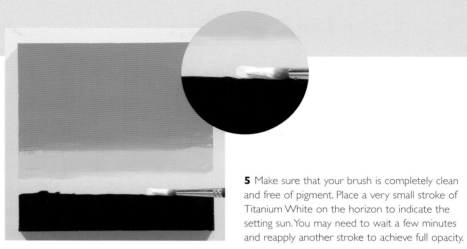

5 Make sure that your brush is completely clean and free of pigment. Place a very small stroke of Titanium White on the horizon to indicate the setting sun. You may need to wait a few minutes and reapply another stroke to achieve full opacity.

Using paint directly from the tube eliminates the difficulty that comes with mixing your own colors.

3 Wait a few minutes for the paint to dry, then fill in the remaining space at the top of the paper, canvas, or panel with full-strength Cadmium Red Medium. Depending on the quality of your paint, you may need to apply an additional layer when the paint is dry, to achieve the desired opacity.

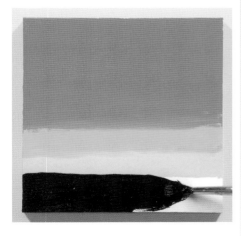

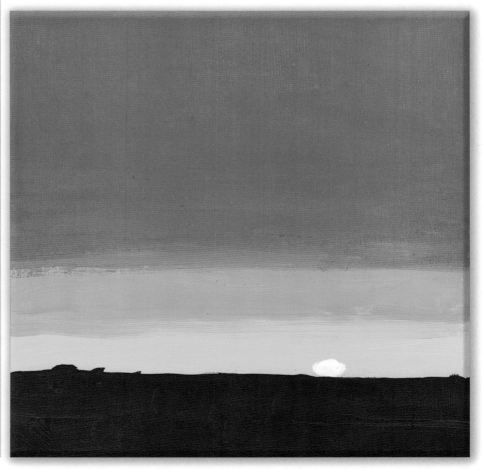

4 Using Mars Black at full strength, fill in the silhouette of the foreground. Add a few small bumps on the horizon to give the indication that there are trees and bushes in the distance. Wait 10 minutes for this to dry before proceeding to step 5.

3 | Basic color mixing:
Pasture scene

Materials

- White paper, canvas, or gessoed panel
- #8 round brush
- Palette
- Water
- Acrylic painting medium

Color palette

- Yellow Ochre
- Unbleached Titanium
- Ultramarine Blue
- Cadmium Yellow Light
- Mars Black
- Titanium White

Try these

Although there are countless varieties of pre-mixed colors available at the art supply store, it is wise to learn how to mix the ones you need using just a few basic colors. Not only will this allow you to mix specific colors that are unavailable at the store but it will also help to keep your color groups unified and harmonious. For this project, you will be mixing a very narrow range of colors: yellows, greens, and blues. Be sure to mix them completely on the palette and apply the mixed color directly to the surface of the paper, canvas, or panel.

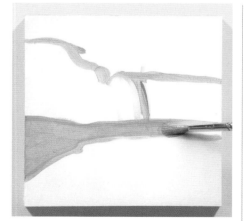

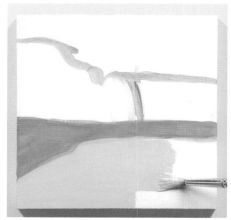

1 Loosely sketch in the outlines of some trees and a pasture using Yellow Ochre. Fill the middle shape with Yellow Ochre. It may take two layers to cover the surface with fully opaque paint.

2 Add some Unbleached Titanium to the Yellow Ochre you were using in step 1 and use this mixture to fill in the foreground shape. It may take you a few tries to get the mixture correct, but don't let that frustrate you. Mixing accurate color takes a bit of practice.

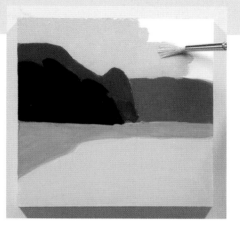

5 Mix Titanium White with a small amount of Ultramarine Blue and use this color for the sky. To finish the painting, allow the sky to dry for 15 minutes and then paint a bank of clouds using Titanium White. You may need to add a second or third layer of white to fully cover the blue color.

Learning to mix colors accurately takes a bit of practice but it's well worth the effort. You will use this skill for every project that follows in this book.

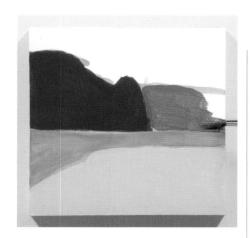

3 To paint the trees, create your own green using a combination of Ultramarine Blue and Cadmium Yellow Light. Experiment with different quantities of yellow and blue to get the color you desire. Add a little Unbleached Titanium to the green to paint the more distant trees on the right.

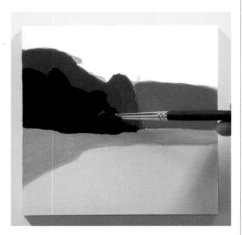

4 To create the color for the shadows on the trees, mix Mars Black with Cadmium Yellow Light. Mixing black and yellow to make green—rather than blue and yellow—often results in a much richer and more opaque green, which is especially useful when painting the shadow colors in trees.

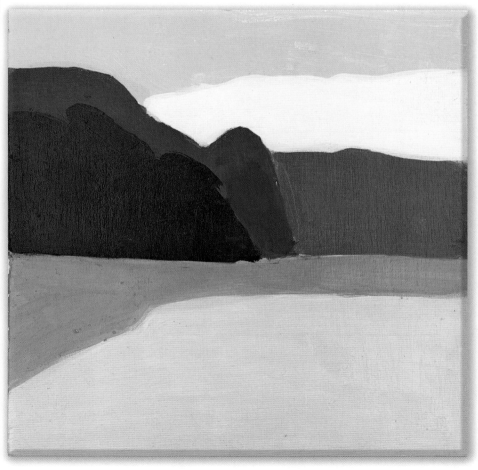

4 | Simple gradations:
Deep blue sea

Materials

- White paper, canvas, or gessoed panel
- #10 round brush
- Palette
- Water
- Acrylic painting medium

Color palette

- Yellow Ochre
- Unbleached Titanium
- Light Blue Permanent
- Titanium White
- Cobalt Blue

Try these

7

9

23

29

31

39

One of the more difficult techniques for the acrylic painter to learn is the ability to paint a smooth, uniform gradation over a large area. Because acrylic paint dries so quickly (in contrast to the slow drying time of oil paint), uniform transitions can be quite challenging. Here are a few things to keep in mind when painting gradations: Lighten the pressure you exert on the brush as you mix one color into the next; add small amounts of the second color to the first color as you progress with the gradation; use a soft brush, since a stiff brush will scrape the surface and make it impossible to paint a smooth gradation.

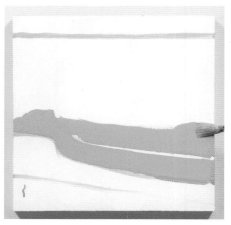

I Sketch a very basic outline of an ocean and beach with a thin mixture of Yellow Ochre and Unbleached Titanium. The straight line at the top will represent the horizon and the curved lines near the bottom will represent the area where the water meets the beach.

2 To begin painting the gradation, mix Light Blue Permanent with Titanium White and apply this color to the water nearest the beach. Leave a small sliver of the white surface unpainted to represent a wave cresting near the beach. Proceed quickly to step 3 before this layer has a chance to dry.

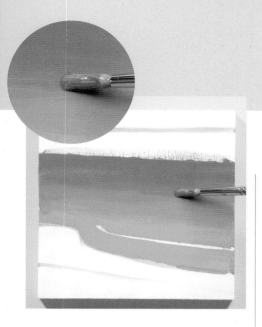

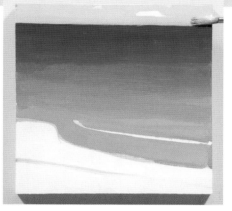

5 To complete the painting, fill in the sky with a mixture of Titanium White and Light Blue Permanent. Leave a little white showing through to suggest clouds on the horizon. Paint the beach with pure Unbleached Titanium. As you apply the color for the beach, maintain a good, clean edge between the beach and the water.

3 Add a small amount of Cobalt Blue to the color mixture you used in step 2. As you fill in the blue color of the water, work from bottom to top using horizontal strokes (this will add to the illusion of waves in the water). Keep adding more Cobalt Blue to the mixture as you approach the horizon line.

You may need to attempt this lesson a few times before you are able to create a smooth gradation that you are happy with. Keep trying! It will get easier with practice.

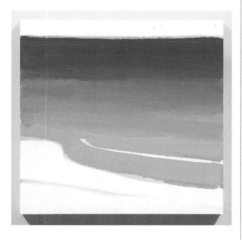

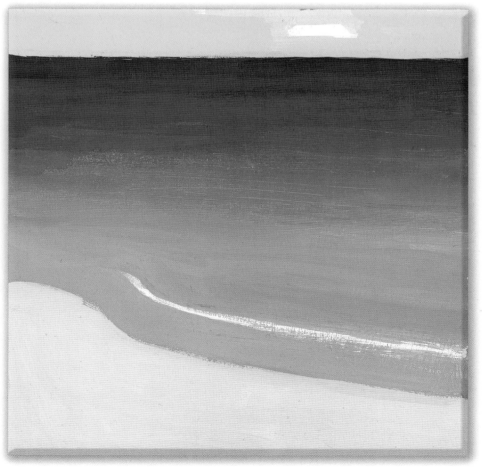

4 Continue this process until the entire shape is filled in with a smooth gradation. The color at the horizon should be pure Cobalt Blue. If you are struggling to get the gradation as smooth as you would like, allow this layer to dry and repeat steps 2 through 4 until you are satisfied with the result (remember, it takes some practice).

5 | Using the white of the canvas: **Rowing boat**

Materials

- White paper, canvas, or gessoed panel
- #10 round brush
- Palette
- Water
- Acrylic painting medium

Color palette

- Yellow Ochre
- Mars Black
- Titanium White
- Unbleached Titanium
- Cadmium Yellow Light
- Cobalt Blue

Try these

When using acrylic paint, it is often difficult to obtain opaque color without applying multiple layers. This is due to the fact that the pigment load (see Acrylic paint, pages 16–19) in certain colors tends to be somewhat low, resulting in colors that are semi-transparent. One way around this problem is to use the color of your paper, canvas, or panel (white in this case) rather than paint a new layer. It takes a bit of planning but if you know ahead of time which areas will be white, you can simply leave them unpainted to achieve the opaque color you desire.

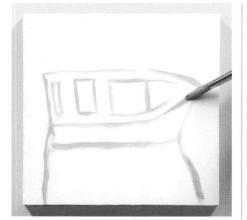

1 Sketch a simple outline of a boat and the boat's reflection in the water using Yellow Ochre. It will help if you make your lines fairly accurate so that you won't need to clean up any areas with white at the end of the exercise. Wait a few minutes for the sketch to dry.

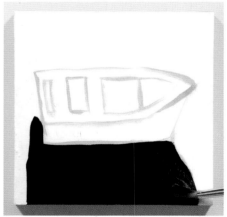

2 Use full-strength Mars Black to indicate the reflection in the water beneath the boat. Smooth out the brushstrokes as you work by gradually reducing the amount of pressure you apply to the brush. Keep the unused black paint on your palette as you will be using it in the next step.

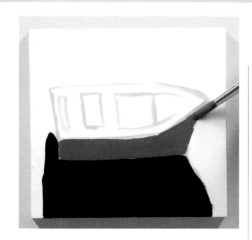

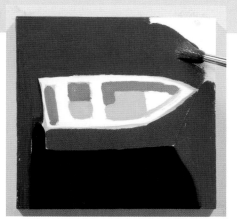

5 Combine Cadmium Yellow Light with Unbleached Titanium to color the floor of the boat. Next, mix Cobalt Blue with a small amount of Mars Black and Titanium White to create a blue color for the water. Fill in the water surrounding the boat.

If a color doesn't have the opacity to cover the other colors you are using, try painting your surface with that color first and then add the other colors around it.

3 Add Titanium White to the Mars Black you used in step 2 and apply this color to the side of the boat. Maintain a sharp edge where the gray meets the white so you won't have to repaint that area later. Keep this color on your palette for use in step 4.

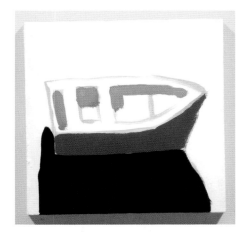

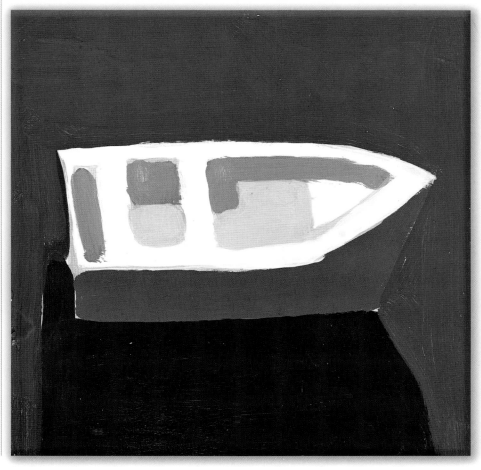

4 Add some Unbleached Titanium to the mixture you used in step 3 and use this color to fill in the shadows on the inside of the boat. Again, be careful not to paint over the areas of the boat that will remain white.

6 | Applying a simple glaze: Bread and butter

Materials

- White paper, canvas, or gessoed panel
- #10 round brush
- Palette
- Water
- Acrylic painting medium

Color palette

- Unbleached Titanium
- Yellow Ochre
- Burnt Sienna
- Titanium White
- Mars Black
- Cadmium Yellow Light

Try these

Painting simple objects is one of the most effective ways to get an introduction to any medium. A piece of sliced bread makes for a great subject because it is essentially a square with a fancy top. In this exercise, you will be introduced to the technique of glazing, which involves applying a thin, transparent layer of paint over a layer that has already dried. It is important to add a little acrylic painting medium to your color mixture to ensure that your transparent glaze will adhere to the dry paint.

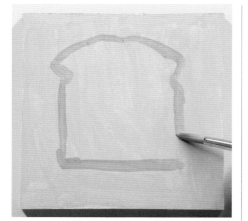

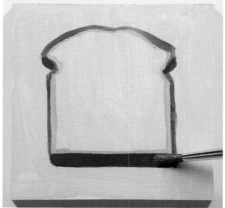

1 Begin by covering your paper, canvas, or panel with Unbleached Titanium. Allow this layer to dry completely. Paint a simple outline of a slice of bread with Yellow Ochre.

2 To paint the crust on the bread, apply Burnt Sienna to the outer edge of the outline you painted in step 1. Be sure to leave a little of the Yellow Ochre showing to make the crust look more realistic. Make the line thicker at the bottom of the bread to create a sense of depth.

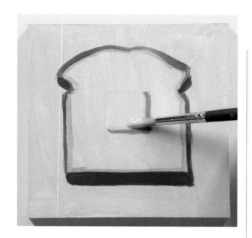

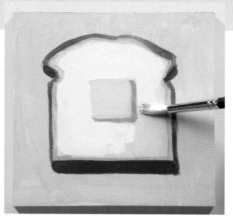

5 To complete the painting, add more Titanium White to the glazing mixture from step 4 and fill in the bread. Make sure to leave a little space near the crust. Mix Burnt Sienna with a little Mars Black to paint shadows on the crust. Use Unbleached Titanium to fill in the background and clean up any stray brushstrokes.

When glazing wet paint over dry, it is important to learn to control the amount of pigment in the mixture. We will revisit the idea of glazing and layering several times in this book.

3 Mix Titanium White with a small amount of Mars Black and use this color to paint a thin gray shadow in the middle of the bread (the shape is a reverse "L"). Next, paint the square of butter with full-strength Cadmium Yellow Light. Allow the painting to dry completely for about 20 minutes before proceeding to the next step.

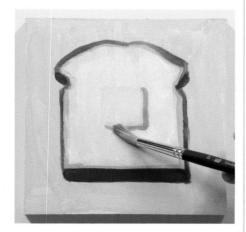

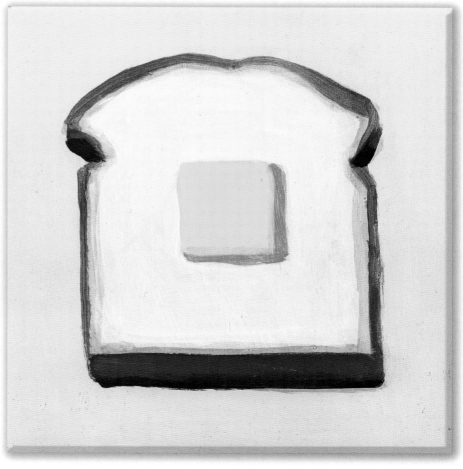

4 When the painting has dried completely, mix a very small amount of Titanium White with some acrylic painting medium and apply a transparent layer to the entire interior of the bread slice. Cover the butter pat and the shadow as well.

7 | Introduction to values:
Misty mountains

Materials

- White paper, canvas, or gessoed panel
- #10 round brush
- Palette
- Water
- Acrylic painting medium

Color palette

- Ultramarine Blue
- Mars Black
- Burnt Sienna
- Unbleached Titanium
- Titanium White

Try these

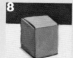

When used in drawing and painting, the term "value" refers to the lightness or darkness of a color (as opposed to the term "hue," which refers to the name of the color, such as "red" or "blue"). A light value is closer to white, a dark value is closer to black, and a medium value is halfway between white and black. For the purpose of this book, value will be separated into five categories: dark, medium-dark, medium, medium-light, and light. This concept is incredibly useful to help the painter better organize complicated compositions by limiting the number of values present in a painting.

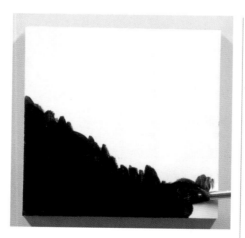

I Begin by painting the foreground trees in a dark value with a mixture of Ultramarine Blue, Mars Black, and a little Burnt Sienna (which will keep the color from becoming too cool). Simplify the shapes of the trees rather than try to render each individual branch and needle.

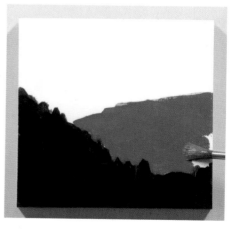

2 Add Unbleached Titanium and Ultramarine Blue to the mixture you used in step I and use this medium-dark value to paint the mountainside in the middle distance. Note: As the hills progress farther into the distance, the value of each individual shape will become lighter with each layer.

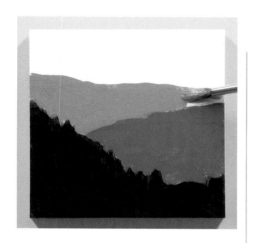

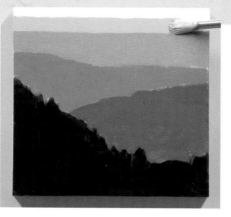

5 To complete the painting, add more Unbleached Titanium to the mixture and paint the final row of hills at the horizon. Paint the sky by adding Titanium White and Unbleached Titanium to the mixture you've used so far. Make any necessary adjustments to the edges, colors, and values.

Simplify complicated compositions by limiting the number of separate values you use in the painting. Also see project 26 (pages 88–89) for another example of this principle.

3 Add more Unbleached Titanium to the mixture and paint the next hill in the distance. This color will have a medium value. To add to the illusion of distance, gradually flatten the silhouettes of the hills as they get closer to the horizon.

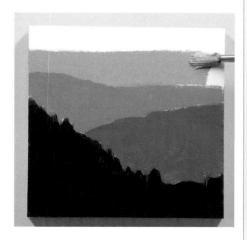

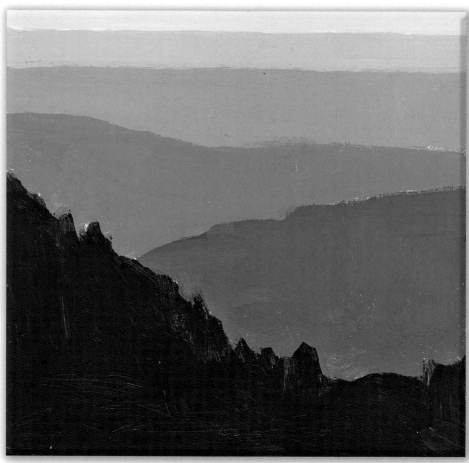

4 Add more Unbleached Titanium to the mixture to create a medium-light value and paint the next hill. The top should be almost perfectly horizontal. A helpful thought to keep in mind is to imagine that, as the hills recede into the distance, there is more "atmosphere" between the viewer and the distant hills. This atmosphere desaturates and lightens all colors.

8 | Understanding light, shadow, and planes: Cardboard box

Materials

- White paper, canvas, or gessoed panel
- #8 round brush
- Palette
- Water
- Acrylic painting medium

Color palette

- Unbleached Titanium
- Yellow Ochre
- Burnt Sienna
- Cadmium Orange

Try these

 6
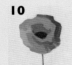 10
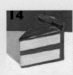 14

 36
 37
 38

In order to convincingly render three-dimensional objects on a two-dimensional surface it is necessary to understand how light and shadow influence the appearance of objects. To introduce this concept, we will be painting an appropriately simple subject: a plain cardboard box. A cardboard box has the shape of a basic cube so you won't need any advanced drawing or painting skills to portray it convincingly. You will just be drawing a cube and filling it in with flat planes of color. To keep this exercise as simple as possible, the colors used will all be various shades of brown and tan.

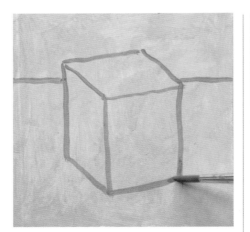

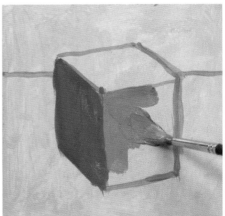

1 To begin, paint a thin wash of Unbleached Titanium over your entire paper, canvas, or panel. When this layer is dry, sketch the outline of the cube using Yellow Ochre. Add a horizontal line behind the box to indicate the edge of the tabletop.

2 With an opaque mixture of Burnt Sienna and Unbleached Titanium, fill in the square on the left plane of the box. This is the shadow side of the box so the value here must be the darkest of the three visible surfaces. Next, add more Unbleached Titanium to the mix and use this color to fill in the plane on the right.

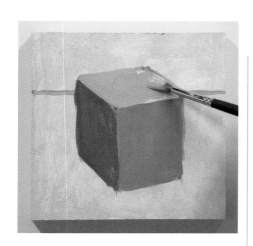

3 Now it's time to paint the top of the box, which is the plane that is receiving the most light. Mix more Unbleached Titanium into the color you have been using until the value is lighter than those on the left and front of the box. Be sure to cover the lines from your initial sketch during this step.

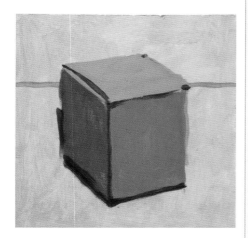

4 Outline the darker, shadow sides of the box with Burnt Sienna. Make the line slightly wider at the bottom of the box to show that there is a shadow underneath. To suggest a lid, set the line along the top of the box slightly in from the left edge, where the top and side meet.

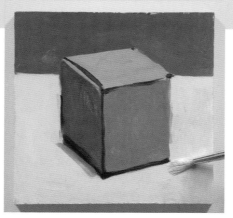

5 Allow the painting to dry for 10 minutes. Create a mixture of Burnt Sienna, Unbleached Titanium, and a little Cadmium Orange and apply this color to the background using the #8 round brush. Paint the tabletop with a mixture of Titanium White and Unbleached Titanium.

As you progress through the projects in this book, try to remember this simple principle: the planes of objects become increasingly darker as they turn away from the source of light.

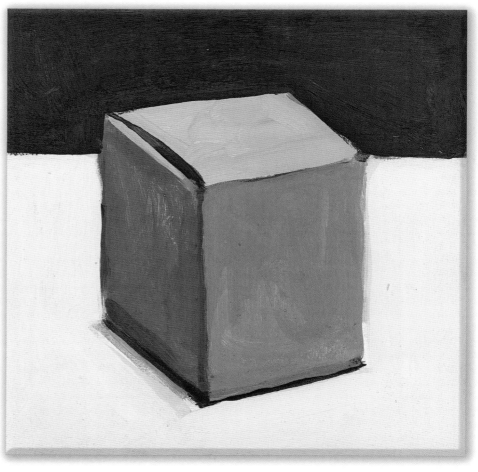

9 | Simple reflections: Sailboat

Materials

- White paper, canvas, or gessoed panel
- #8 round brush
- Palette
- Water
- Acrylic painting medium

Color palette

- Unbleached Titanium
- Yellow Ochre
- Mars Black
- Cerulean Blue
- Burnt Sienna
- Cobalt Blue
- Titanium White

Try these

 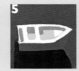

The ability to convincingly paint the illusion of a reflection on water is a useful skill for any artist to learn. Rendering a reflection accurately in a painting imparts a sense of wonder to the viewer, often inviting the question, "How did you do that?" This project will break down the elements of a simple reflection; you will encounter more challenging approaches later in this book. In order to achieve the illusion, keep in mind that the water will mirror the colors and shapes above it.

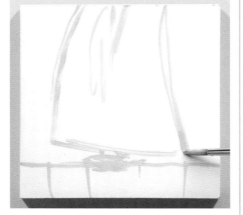 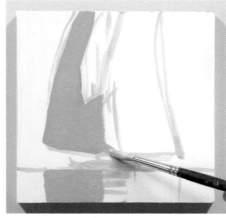

1 With a mixture of Unbleached Titanium and Yellow Ochre, sketch the basic outline of a sailboat, water line, and reflection. Using a warm color for this step will help to balance the cooler colors you will be applying in the following steps.

2 To make a color that will represent the shadow side of the sail, mix Unbleached Titanium with a small amount of Mars Black. Paint the left sail as well as its reflection in the water directly beneath it.

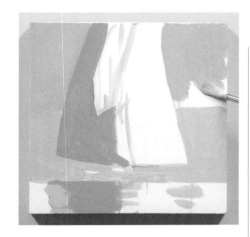

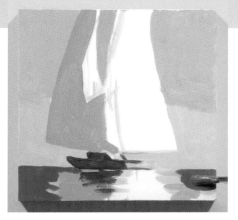

5 To finish the painting, add Cobalt Blue to the water at the edges of the painting. This will give the sense that the water is a deep blue hue. Clean up the white parts of the sails with Titanium White.

Painting an interesting reflection in water is a fairly straightforward affair. Remember to repeat the colors found on the object in the reflection.

3 To give the impression of a distant cloud bank on the horizon, use a mixture of Cerulean Blue and Unbleached Titanium. Apply small, horizontal strokes of this color to the reflection, as well. For the blue sky above the clouds use Cerulean Blue and Titanium White. Apply this to the outer edges of the reflection.

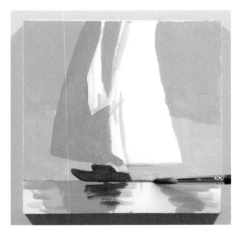

4 To balance some of the cool blues and grays, use Burnt Sienna to render the shadow side of the boat. When painting the reflection in the water, use broken strokes to indicate the waves in the water.

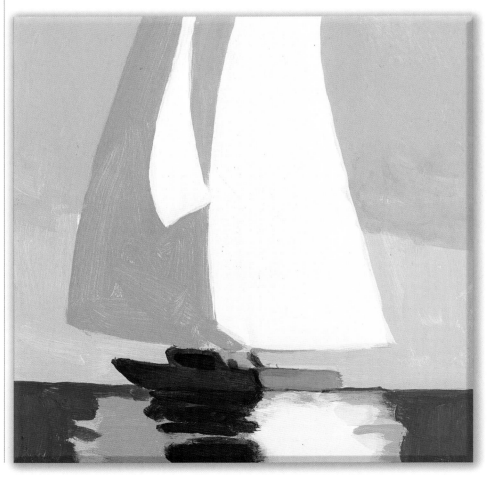

10 Mixing tints and shades:
Red poppy

Materials

- White paper, canvas, or gessoed panel
- #10 round brush
- Palette
- Water
- Acrylic painting medium

Color palette

- Cadmium Red Medium
- Mars Black
- Titanium White
- Cadmium Yellow Light
- Unbleached Titanium

Try these

In the language of color theory, to "tint" a color is to create a lighter version of that color, usually by adding white. To make the "shade" of a color usually involves adding black to make it darker. It is also possible to make tints and shades using other colors (adding dark blue instead of black to create the shade of a color, for example). To keep things simple for this project, you will be mixing tints and shades for a single color: Cadmium Red Medium. You will have a chance to experiment with this technique using other colors in later projects.

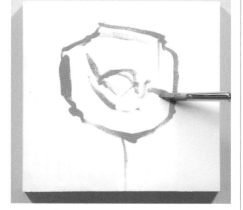

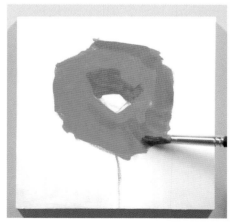

1 Sketch the basic outline of a poppy and its stem with Cadmium Red Medium. Fill the inside of the poppy with Cadmium Red Medium, leaving the center of the flower unpainted. Allow this layer to dry for at least 5 minutes or until dry to the touch.

2 To indicate the subtle shift in color in the shadow areas of the flower, add a very small amount of Mars Black to Cadmium Red Medium. When you have painted the petals on the right with this mixture, add a little more Mars Black and apply this color to the petals on the upper right.

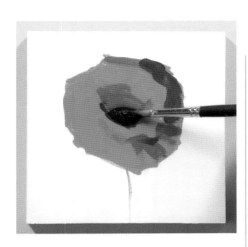

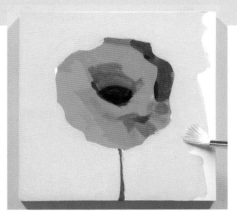

5 When the paint from step 4 has dried completely, fill in the background and clean up any stray brushstrokes using a mixture of Unbleached Titanium and Titanium White. Apply an almost completely transparent glaze of Cadmium Red Medium to the flower to unify the colors further.

Tinting and shading colors with white and black paint is often an easy way to achieve effects of light and shadow.

3 Add more Mars Black to the mixture you have been using until you have a color that is nearly black with the slightest hint of red remaining. Paint the center of the flower and a few accents on the petals with this color. So far, you have used four shades of red for this project.

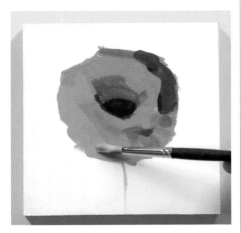

4 Wash and dry your brush completely so you can mix a clean, new color. Tint your red by mixing a very small amount of Titanium White into some Cadmium Red Medium. Paint the petals on the left side of the poppy with this color. Mix Mars Black and Cadmium Yellow Light and paint the stem.

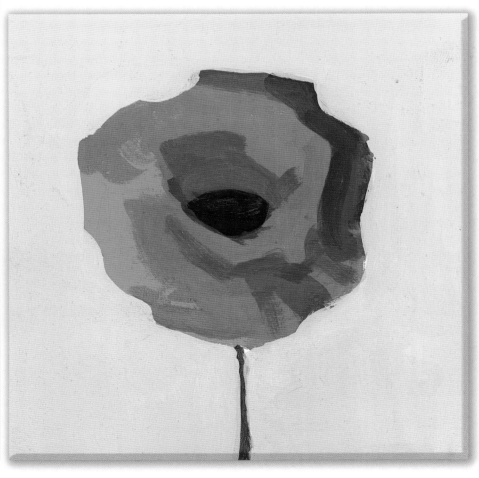

11 | Painting negative space:
Red shoe

Materials

- White paper, canvas, or gessoed panel
- #8 round brush
- Palette
- Water
- Acrylic painting medium

Color palette

- Cadmium Red Medium
- Mars Black
- Titanium White

Try these

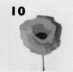

In painting, the term "negative space" refers to the area surrounding an object (this is often referred to as the "background"). When painting in acrylics, it is often difficult to paint small, tight, opaque details due to the lower pigment density of the paint. Because of this, it is often necessary to lay down the base color of the object first and then paint around the object with another color. The long, thin heel of the red shoe in this project would be very difficult to paint directly in a single, opaque layer. By painting the background color around the heel, however, it is easy to get a nice, tight, thin line.

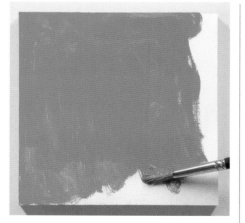

1 To begin the painting, rather than sketch the outline of the shoe first, cover the canvas or panel with an opaque layer of Cadmium Red Medium. Allow this layer to dry for 10 minutes.

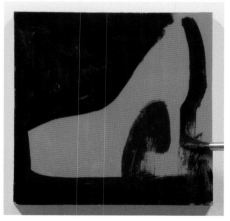

2 For the background color, mix Cadmium Red Medium and Mars Black together to get a reddish-black color. Use this to paint the shape of the shoe by filling in the space around it. If this feels unnatural, draw the shoe first with a pencil and fill in the space around your outline.

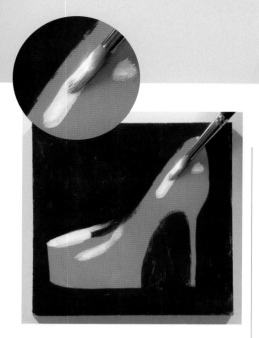

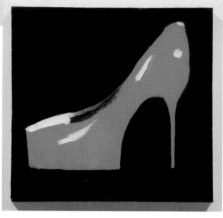

5 Complete the painting by mixing a new, deep red using Cadmium Red Medium and more Mars Black. Re-work the background with this mixture but allow the reflection beneath the shoe to show through. Add a little Mars Black to the red and paint the shadow on the bottom of the shoe.

3 To paint the bright highlights and make the shoe appear glossy, apply dabs of Titanium White. Allow to dry for 2 minutes. Apply a second stroke of the same color to the interior of each highlight, leaving the initial stroke visible at the edge.

Acrylic paint has many advantages over other media—opacity, however, is not one of them. By "cutting out" tight details, you will save yourself the extra steps required to paint clean, opaque shapes.

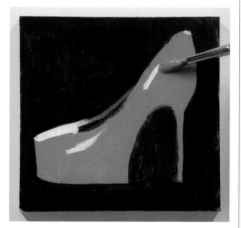

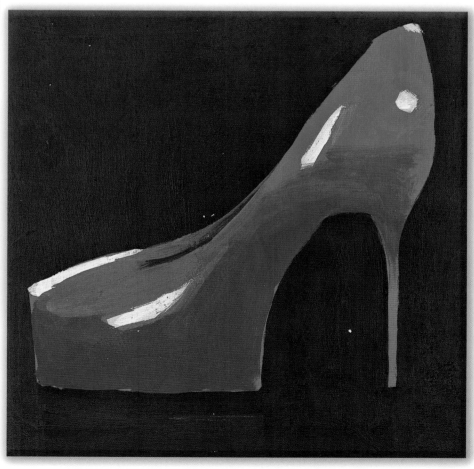

4 Just as you were able to sculpt the shape of the shoe using the surrounding color, you can also fine-tune the highlights by applying Cadmium Red Medium to the surrounding areas. Achieving sharp, tight lines with white paint alone would be quite difficult. Add a little stroke of the same red to indicate the other side of the shoe.

12 | Textured layering:
Color field abstract

Materials

- White paper, canvas, or gessoed panel
- #4 filbert brush
- Palette
- Water
- Acrylic painting medium

Color palette

- Cerulean Blue
- Titanium White
- Cadmium Red Medium
- Yellow Ochre

Try these

"Color field" painting is a style of painting that developed in the middle of the 20th century, primarily in New York. Using large, flat shapes of solid color, the pioneers of this style of painting invented an approach that has inspired artists for decades. The process for creating your own color field painting is relatively straightforward: You will tone the surface first, then divide the area into interesting proportions and lay in simple rectangles of semi-transparent color. Because you are working with so few elements, it is important to make each of those elements as appealing as possible.

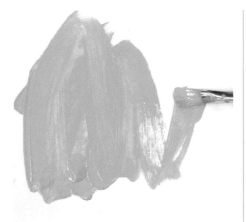

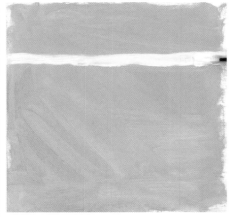

1 To begin, use a thin, transparent wash of Cerulean Blue mixed with a little Titanium White to tone the surface. Be sure to leave some texture in the brushstrokes; a completely smooth, opaque field will be less interesting than one with a bit of texture.

2 Using full-strength Titanium White, paint a line horizontally across the painting. Pay special attention to the placement of your line. If it is too close to the center, the composition will be too even and static. Somewhere between a quarter and a third of the total measurement of the area will be best.

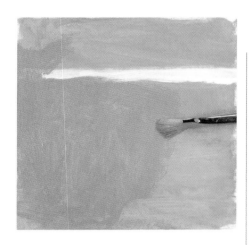

3 Mix a subtle violet-gray by adding a small amount of Cadmium Red Medium to the Cerulean Blue/Titanium White mixture you used in step 1. Add acrylic painting medium to thin the mixture so that the paint adheres to the surface properly. Apply this color over the blue, allowing some of the underlying color to show.

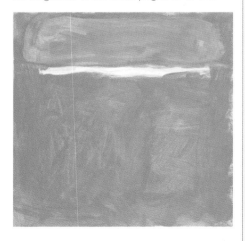

4 When the paint is dry to the touch, add a loose rectangular shape above the white line using a semi-transparent mixture of Yellow Ochre and a little Titanium White. As in previous steps, do not make the shape opaque—allow some of the underlying layers to show through for a more interesting texture.

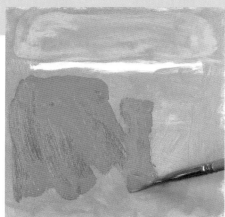

5 For the final shape, apply a layer of Cadmium Red Medium mixed with acrylic painting medium to the area under the white line. Again, allow some of the underlying color to show through. Finally, add a border with a mixture of Cadmium Red Medium and a little Titanium White.

You can explore endless variations on this theme simply by changing the color and placement of the rectangles. For inspiration, research the color field painters and Abstract Expressionists.

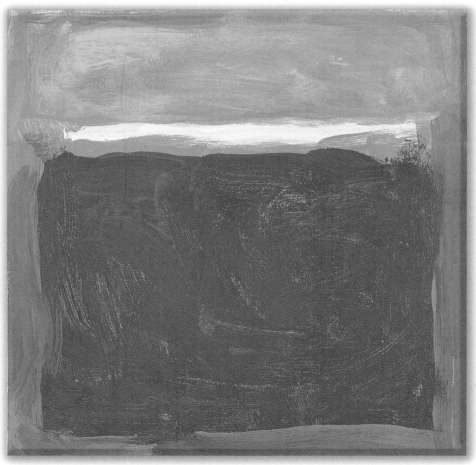

13 | Layering cool over warm colors:
Barn and pasture

Materials

- White paper, canvas, or gessoed panel
- #10 round brush
- Palette
- Water
- Acrylic painting medium

Color palette

- Yellow Ochre
- Cadmium Red Light
- Burnt Sienna
- Unbleached Titanium
- Mars Black
- Cadmium Yellow Light
- Ultramarine Blue
- Titanium White

Try these

 12

 22

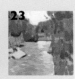 23

 32

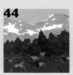 44

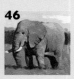 46

When painting outdoor subjects, it is common to find that most of the colors you see outside occupy the "cool" side of the spectrum: blue sky, white clouds, green grass, green trees, etc. If you copy these colors directly from nature, it is likely that you will end up with a group of colors that is narrow and rather uninteresting. An effective way to remedy this is to start with an underpainting using warm earth tones (Yellow Ochre, Burnt Sienna) and allow some of that color to show through as you apply the cooler blues and greens.

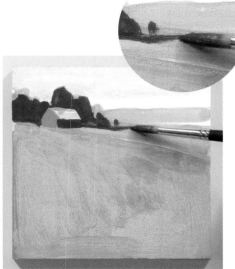

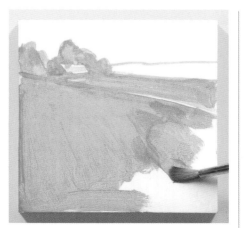

1 To establish the warm-toned underpainting, use Yellow Ochre to paint a series of simplified shapes: large pasture in the foreground, the roof of a barn surrounded by a group of trees, and a distant strip of land at the horizon. Allow the paint to dry for 5 minutes before proceeding to the next step.

2 Paint the face of the barn with Cadmium Red Light. Use Burnt Sienna for the long side of the barn and to define the trees surrounding the barn. At this stage, all of your shapes have been painted with warm colors. In the following steps, you will apply cool colors over the warm underpainting.

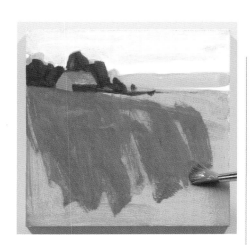

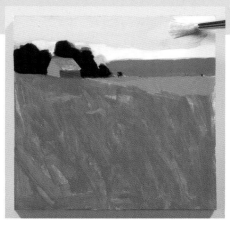

5 Paint the hills in the distance with a mixture of Ultramarine Blue and Unbleached Titanium. Add Titanium White to this mixture and use this color for the sky. Clean up the cloud shape with Titanium White. Add subtle color changes to the trees with a mixture of Cadmium Yellow Light and Mars Black.

3 Be sure that the underpainting has had time to dry completely so that the next layers do not lift the paint from the surface. Paint the rooftop with a mixture of Unbleached Titanium and Mars Black. Mix a light green using Cadmium Yellow Light and Ultramarine Blue and apply this to the foreground.

The technique of underpainting using colors with opposing temperatures can also be reversed. If you find that a painting requires the use of mostly warm colors, try underpainting in blue, green, or violet.

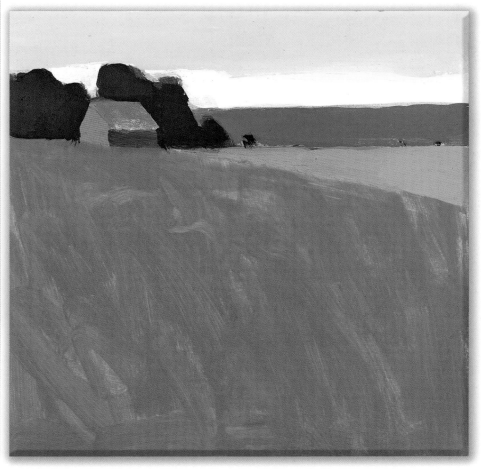

4 Add Unbleached Titanium to the green color from step 3 and paint the thin triangle of pasture in the distance. Next, mix Mars Black with a little Cadmium Yellow Light to make a dark green for the trees near the barn. Remember to allow a little of the warm underpainting to show at the edges.

14 | Rendering objects with simple shapes: Slice of cake

Materials

- White paper, canvas, or gessoed panel
- #8 round brush
- #4 filbert brush
- Palette
- Water
- Acrylic painting medium

Color palette

- Unbleached Titanium
- Cadmium Orange
- Dioxazine Purple
- Alizarin Crimson
- Mars Black
- Titanium White

Try these

 6
 8
 34
 36
 37
 38

For this exercise, you will be painting a very simple object: a slice of cake. A good habit for painters in any medium is to visualize subject matter as arrangements of basic geometric forms. You can effectively portray even the most complicated subject by first seeing it as a combination of spheres, cylinders, pyramids, cones, or cubes. For this slice of cake, visualize a cube that has been cut in half diagonally from corner to corner. This exercise will also help you to develop the ability to convey light and shadow.

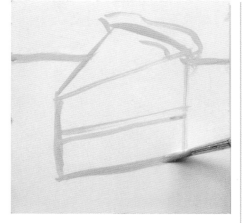

1 Using the #8 round brush, sketch the basic shapes of the cake with Unbleached Titanium. Notice that the shape of the top of the cake is a simple triangle and the rest of the cake is made up of simple rectangles. Add a horizontal line behind the cake to indicate the edge of the table on which it is sitting.

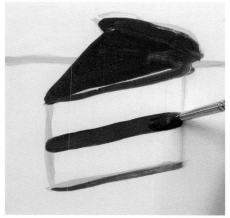

2 For the chocolate parts of the cake, create a rich, dark brown by mixing Cadmium Orange with Dioxazine Purple. Apply to the top of the cake, leaving a thin strip of white showing along the bottom edge to indicate a highlight. Paint bands of the same color on the middle, bottom, and back of the cake.

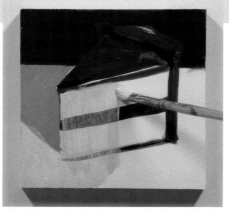

5 Apply a semi-transparent glaze of Unbleached Titanium to the the tabletop and side of the cake. To finish, first paint the layers on the side of the cake with a mixture of Cadmium Orange, Unbleached Titanium, and a little Dioxazine Purple. Next, fill in the tabletop with a mixture of Titanium White with a little Unbleached Titanium.

For more examples of objects rendered using simple geometric forms, research the paintings of American Pop Artist Wayne Thiebaud.

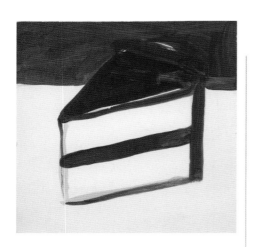

3 Mix Alizarin Crimson, Unbleached Titanium, and some of the rich brown color (Cadmium Orange and Dioxazine Purple) you've used for the cake so far. Using the #4 filbert brush, apply this color as a semi-opaque wash to the background, above the tabletop.

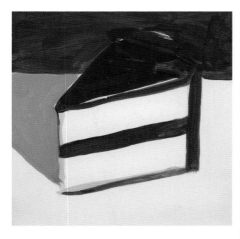

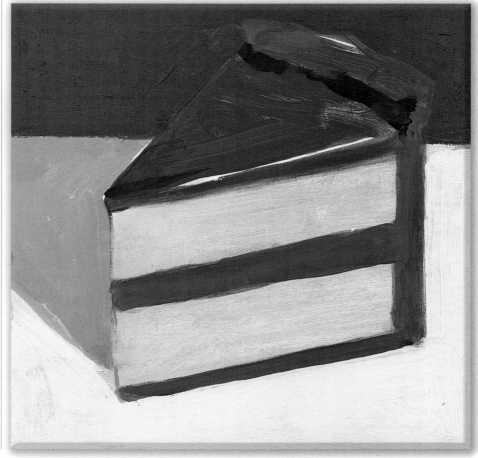

4 To create the illusion that light is hitting the cake, paint the shadow cast by the cake onto the table. Combine Unbleached Titanium and a very small amount of Mars Black to create a medium-value gray. Apply this color to the left of the cake. Remember that the cake has a straight edge so the shadow will have a straight edge too.

15 | Light, shadow, and value outdoors:
Road and grass

Materials

- White paper, canvas, or gessoed panel
- #10 round brush
- Palette
- Water
- Acrylic painting medium

Color palette

- Yellow Ochre
- Cadmium Yellow Light
- Cobalt Blue
- Unbleached Titanium
- Cadmium Orange
- Burnt Sienna
- Mars Black

Try these

In project 7 (pages 48–49), you learned that the "value" of a color is its relative lightness or darkness. This is important knowledge because convincingly painting a cast shadow over two surfaces of different value requires that you change the value by the same number of steps on each surface. For instance, if one surface is a light value and the other is a medium value, the shadows for each surface will need to get darker by two shades. The light surface will have a medium-value shadow and the medium-value surface will have a dark-value shadow. Keeping these relationships consistent is the key to representing convincing light and shadow patterns in your paintings.

1 Begin with a basic outline of the shapes using Yellow Ochre. Pay special attention to the perspective on the road: Make sure that it gets gradually smaller as it winds into the distance. Allow this layer to dry before proceeding to the next step.

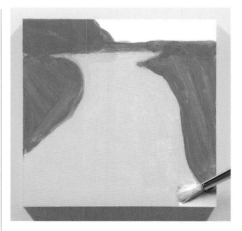

2 Mix Cadmium Yellow Light with Cobalt Blue and fill in the grassy areas. This green should be of medium-light value. Next, mix Unbleached Titanium with a very small amount of Cadmium Orange to fill in the road shape. This color should be a light value.

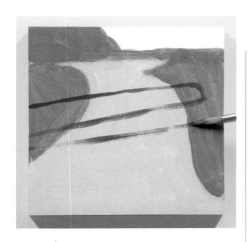

5 Just as you made a two-step drop in value in the grass shadow, now make a two-step drop from light to medium for the road shadow by mixing Unbleached Titanium, Mars Black, and a little Burnt Sienna. Fill in the shadow on the road with this color. Paint the sky with a mix of Cobalt Blue and Titanium White.

The shadows in this painting look convincing because the values are in the correct relationship to the values in the light areas of the painting.

3 Use Burnt Sienna to draw the edges of the shadows being cast on the road and grass. For this exercise, the shadow shapes will be very simple. As you progress in your skills you can experiment with more complex shapes and the effects of dappled light.

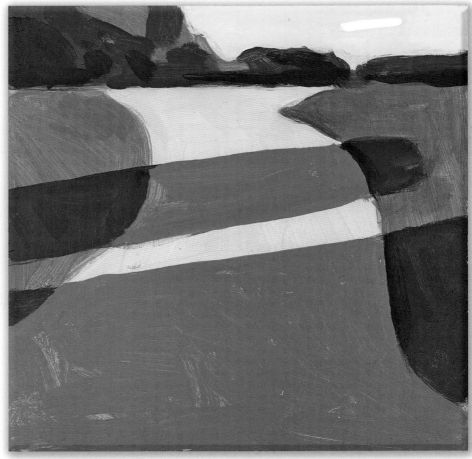

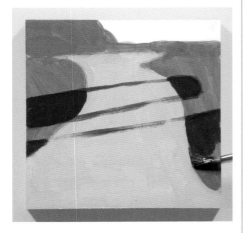

4 Combine Mars Black and Cadmium Yellow Light to make a medium-dark value green for the shadows on the grass. Note that you are making a value that is two shades darker (from medium-light to medium-dark). Use this darker green to establish a few shadows in the distant trees as well.

16|Layering opaque over transparent:
Summer tree

Materials

- White paper, canvas, or gessoed panel
- #10 round brush
- #4 filbert brush
- Palette
- Water
- Acrylic painting medium

Color palette

- Cobalt Blue
- Titanium White
- Cadmium Yellow Light
- Mars Black
- Phthalo Blue
- Burnt Sienna

Try these

 12
 13
 22
 23
 32
 46

Acrylic paint has one distinct advantage over any other medium: You can build multiple layers of paint quickly thanks to the fast drying time. For this project, you will be experimenting with layering different thicknesses of paint by varying the amount of painting medium added to the paint. You will start with thin, transparent washes and slowly add more pigment to the mixture as you progress, allowing time for the layers to dry as you work. The final layer will consist of thick, opaque paint. Using this technique will add a pleasing element of variety to the surfaces of your paintings.

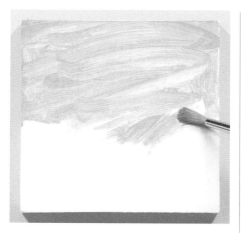

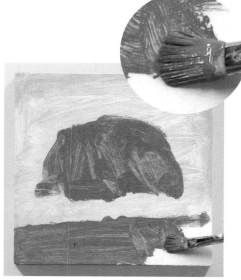

1 Using the #10 round brush, cover the paper, canvas, or panel with a thin, transparent mixture of Cobalt Blue and Titanium White. Pay special attention to how the paint reacts when you change the amount of pressure you exert on the brush. Softer pressure will make for a smoother, more uniform finish.

2 With the #4 filbert brush, mix Cadmium Yellow Light with small amounts of Cobalt Blue and Mars Black to make a green color. Apply this to the foliage and grass. Be aware of the thickness of the paint: It should be just slightly thicker than the consistency of the paint you used in step 1.

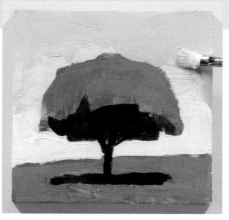

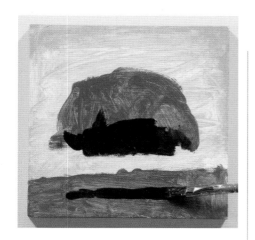

3 For the shadow colors on the tree and grass, mix Cadmium Yellow Light, Mars Black, and a very small amount of Phthalo Blue. Using the #4 filbert brush, apply this color using paint that is just a little thicker than the paint you used in the previous step.

5 The final layer of paint will be the thickest so far. Paint the sky with Titanium White near the horizon and add some Cobalt Blue at the top with the #4 filbert brush. Your brushstrokes should be quite visible at this point. Complete the painting by adding one more layer of green (Cadmium Yellow and Cobalt Blue) to the tree and grass.

Building progressively thicker layers of paint will add dimension and interest to the surface of your painting.

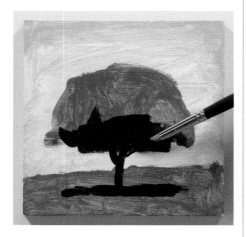

4 To paint the trunk and branches of the tree, mix Burnt Sienna with a very small amount of Mars Black. To ensure that the lines are sharp, gently roll the #10 round brush on the palette while picking up the paint so that the brush has a sharp point. Allow the painting to dry for 10 minutes before proceeding to step 5.

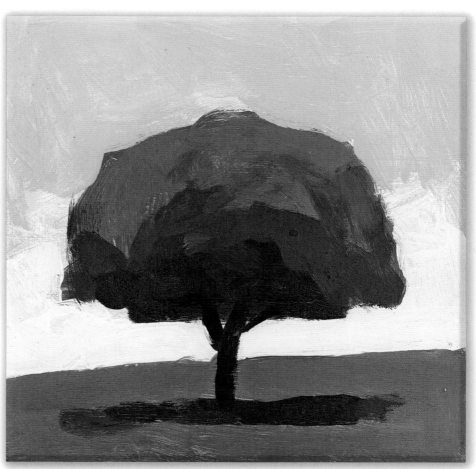

17 | Layering over an underpainting: **Tree silhouette**

Materials

- White paper, canvas, or gessoed panel
- #6 round brush
- #4 filbert brush
- Palette
- Water
- Acrylic painting medium

Color palette

- Dioxazine Purple
- Cadmium Orange
- Cadmium Yellow Light
- Cadmium Red Medium
- Titanium White

Try these

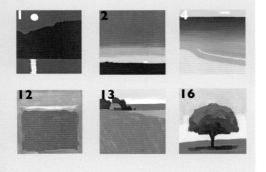

Painting a tree silhouetted against a vibrant sky is a motif that can be modified in countless ways to produce a wide variety of beautiful results. Because this is a relatively simple image to execute, try painting it multiple times, substituting different species of tree as well as different types of sky. The technique you will be using involves layering thin, transparent paint over a dark, nearly opaque underpainting. This method is ideally suited to the acrylic painter because each layer dries quickly, allowing for rapid build-up of the colors. Glazing thin layers will also give your paintings a luminosity that cannot be achieved with opaque color alone.

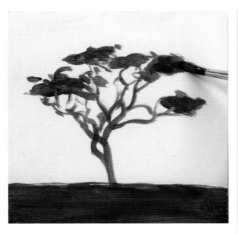

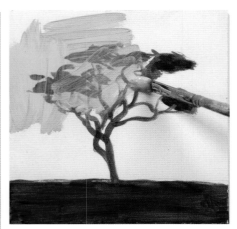

1 With a diluted mixture of Dioxazine Purple and Cadmium Orange, paint the basic silhouette of the tree and the foreground using the #6 round brush. You will be painting over this layer in the next few steps so don't worry about rendering the tree perfectly. Wait for this stage to dry completely before proceeding to the next step.

2 Now apply a nearly opaque glaze of Cadmium Yellow Light and acrylic painting medium directly over the tree using the #4 filbert brush. Allowing the textured brushstrokes to show will create the illusion of bands of clouds in the finished painting.

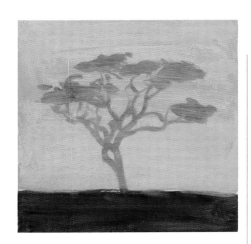

3 Next, using the same brush, mix a little Cadmium Orange into the Cadmium Yellow Light you have been using. If the Cadmium Yellow Light layer is still wet, you can feather the Cadmium Orange into the wet paint. If the yellow layer is dry, feather by reducing the amount of pressure you apply to the brush.

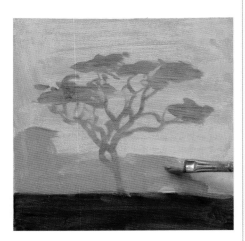

4 Mix equal parts of Cadmium Red Medium and Cadmium Orange and use this mixture to paint the clouds nearest the horizon. Leave a little yellow spot at the horizon to represent the setting sun. Start at the bottom and work your way up, adding Cadmium Orange to the mixture as you go higher in the sky.

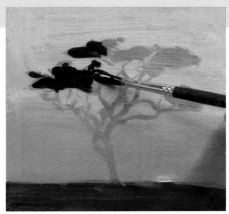

5 You should still have just enough of the original tree silhouette showing through the layers of paint to use as a guide. Mix Dioxazine Purple and Cadmium Orange to make a deep brown, use this color to emphasize the tree and foreground using the #6 round brush. Place a final dab of Titanium White inside the setting sun to give it some additional brightness.

Relying on an underpainting in the early stages of a project eliminates the fear that comes with the expectation that every stroke must be final. Acrylic paint is perfectly suited for layering because of its fast drying time.

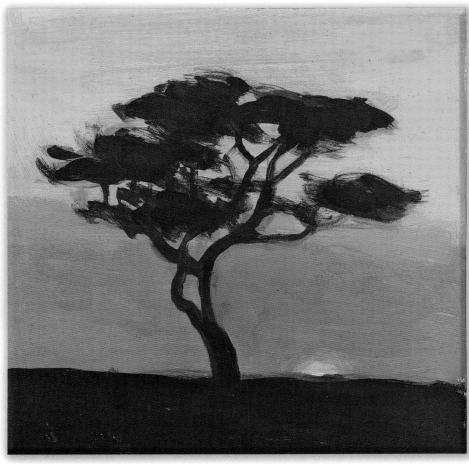

18 | Layering a simple abstract design:
Yellow circles

Materials

- White paper, canvas, or gessoed panel
- #10 round brush
- #4 flat brush
- Palette
- Water
- Acrylic painting medium

Color palette

- Yellow Ochre
- Unbleached Titanium
- Cadmium Yellow Light
- Cadmium Orange
- Titanium White
- Cobalt Blue

Try these

 12

 24

 30

 31

 34

 35

People often assume that abstract paintings are entirely random, executed without any planning or use of design principles. This is far from true. While randomness plays a vital role in much abstract painting, having a few ideas established before you start can help immensely. The simple principles for this project will be these: Every shape will be a circle; every shape will be slightly different in size from the shape that preceded it; and all of the shapes will be painted with analogous colors (colors that are next to each other on the color wheel). Perhaps it seems counterintuitive, but imposing these limitations will free you to focus on making an appealing abstract design.

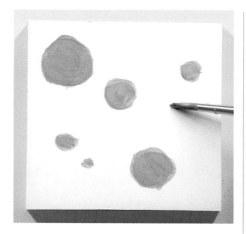

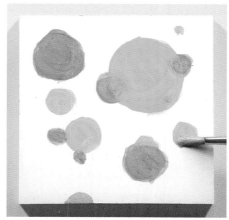

1 Using the #10 round brush, paint seven circles of unequal size at random places on your paper, canvas, or panel. Use Yellow Ochre with a very small amount of Unbleached Titanium added to improve opacity. Try to make the circles occupy the area equally. Leave the paint to dry for 5 minutes.

2 Add Cadmium Yellow Light and Cadmium Orange to your mixture and paint seven new circles overlapping the original seven. Again, do your best to make the circles of unequal size. It may be helpful to start with a large circle and make each subsequent circle slightly smaller.

5 When you are satisfied with the arrangement and coloring of the circles, complete the painting by painting the background with a mixture of Titanium White and Cobalt Blue using the #4 flat brush. This color will be a good complement to the yellows and oranges of the circles.

3 Allow the paint to dry. Now use full-strength Cadmium Yellow Light to create the next seven circles. Notice how each set of circles begins with a circle that is larger than any you used in previous steps. This helps to unify the circles in an interesting way.

Like many abstract painting projects, this exercise can be repeated an endless number of times using different colors and shapes.

4 Experiment with the transparency and opacity of the overlapping circles by repainting some of the parts opaque and leaving other parts transparent. To keep your colors consistent, simply use mixtures of the colors you have used thus far. Allow the paint to dry for 10 minutes.

Chapter 3

Beyond the basics

Now that you have a grasp on the
fundamentals of acrylic painting, it is
time to move on to more advanced
projects. In this chapter you will
be introduced to a series of design
principles and brushstroke techniques
as well as techniques for creating
more expressive paintings.

19 | Using contour strokes:
Ball of yarn

Materials

- White paper, canvas, or gessoed panel
- #10 round brush
- Palette
- Water
- Acrylic painting medium

Color palette

- Cadmium Red Medium
- Unbleached Titanium
- Burnt Sienna
- Mars Black
- Cadmium Orange

Try these

10 **11** **20** **21** **34** **46**

Rendering a three-dimensional object on a two-dimensional surface requires that you employ some illusionistic tricks. One such trick is to suggest form or roundness with what are called "contour strokes." Contour strokes appear to bend around the object and give the illusion of three-dimensional form. You will execute more difficult versions of this exercise in the coming projects, but for now let's start by rendering a simple sphere: a ball of red yarn.

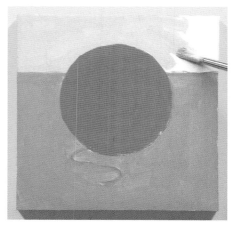

1 Paint an opaque ball with Cadmium Red Medium. Add a horizontal line to indicate the back of the tabletop and a squiggle to show a loose strand of yarn. It's fine if the edges of the ball are somewhat imperfect; this will only add to the illusion of a ball of yarn.

2 While the red paint is drying, fill in the tabletop using a mixture of Unbleached Titanium, Burnt Sienna, and Mars Black. Fill in the background with Unbleached Titanium. Wait until the red ball is dry to the touch (10 minutes or so) before proceeding to the next step.

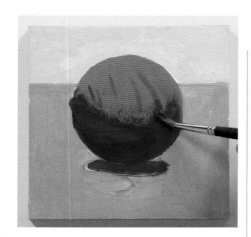

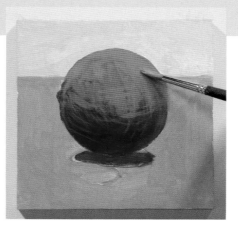

5 Add a small amount of Cadmium Orange to some Cadmium Red Medium and repeat the technique from step 4, but this time on the top of the ball of yarn. Do not cover the underlying color completely; just use contour strokes to render the individual strands of yarn. To complete the painting, darken the cast shadow under the ball.

Contour strokes can be used in a variety of situations. Any time you wish to show that your subject has three-dimensional form and volume, contour strokes will be useful.

3 Notice that the light hitting the ball of yarn is coming from directly overhead and casting a shadow on the bottom half of the sphere. Mix a small amount of Mars Black with some Cadmium Red Medium and apply this to the crescent-shaped shadow area on the lower portion of the ball.

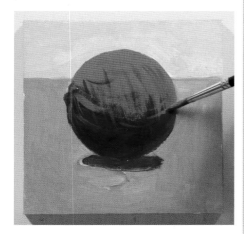

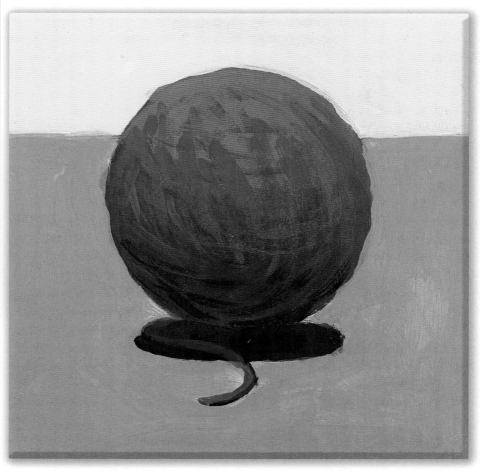

4 When the paint is dry to the touch, begin applying the contour lines over the shadow using Cadmium Red Medium. Each stroke you paint will represent a strand of yarn so keep your strokes thin. Use fewer brushstrokes as you get closer to the bottom of the ball.

20 | Using hatching strokes:
Bird's nest

As you have learned in project 19 (pages 74–75), it is possible to create the illusion of form in a painting simply by using directional brushstrokes. In much the same way as a bird will build its nest one stick at a time, you can "build" your nest painting one brushstroke at a time. As you progress through the steps, keep in mind that you will be using one set of lighter colors to represent the sticks and one set of darker colors to represent the spaces between the sticks.

Materials

- White paper, canvas, or gessoed panel
- #8 round brush
- Palette
- Water
- Acrylic painting medium

Color palette

- Yellow Ochre
- Burnt Sienna
- Mars Black
- Cobalt Blue
- Unbleached Titanium
- Titanium White

Try these

 19
 21
 22
 23
 30
 46

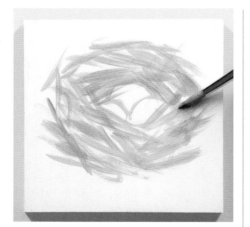

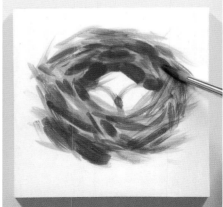

1 Position the nest in the center of your paper, canvas, or panel by outlining a basic oval shape. Begin filling it in with directional "hatching" strokes using Yellow Ochre, which will form the base tone for the nest. Suggest the outlines of three eggs at the bottom of the nest.

2 Add strokes of Burnt Sienna following the directional strokes you painted in step 1. Make sure you allow some of the Yellow Ochre to show through. These strokes will represent the spaces between the sticks so the strokes should be slightly wider than the ones you used in step 1.

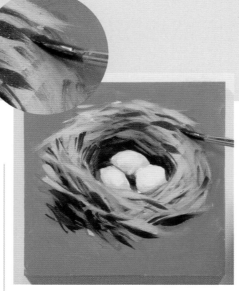

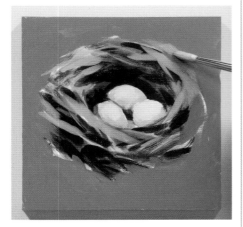

3 Add a small amount of Mars Black to some Burnt Sienna and use this color to deepen the tone in the shadows. Use the brushstrokes from step 2 as a guide for the placement of the new, darker hatchmarks. This color represents the deepest recesses of the nest.

5 Continue to develop the illusion of layered sticks that make up the nest. To represent the sticks at the surface, vary the mixture of Unbleached Titanium and Yellow Ochre. For the shadow spaces between the sticks, use Burnt Sienna, occasionally adding Mars Black to the mixture for the darkest shadow spaces. To complete the painting, use this dark brown to indicate a tree branch under the nest.

The illusion of dimension and form is often achieved using directional brushstrokes. See projects 19 (pages 74–75) and 46 (pages 130–131) for more examples.

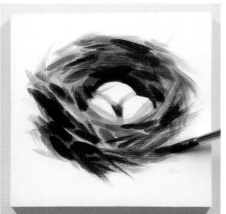

4 Fill in the background with a mixture of Cobalt Blue and Unbleached Titanium. Paint a layer of light-colored sticks at the top of the nest using a mixture of Unbleached Titanium and Yellow Ochre. Use a Mixture of Titanium White and Cobalt Blue to paint the eggs.

21 | Using expressive strokes:
Flowers in a glass

Materials

- White paper, canvas, or gessoed panel
- #8 round brush
- Palette
- Water
- Acrylic painting medium

Color palette

- Cadmium Yellow Light
- Cadmium Orange
- Cadmium Red Medium
- Unbleached Titanium
- Mars Black
- Titanium White
- Cobalt Blue

Try these

Nearly all of the projects in this book follow the same basic approach: Draw or sketch an outline of an object and proceed to fill it in with various colors. For this exercise, however, there will be no initial planning or outlining; you will simply create the shapes for the flowers by scribbling (also called "hatching") inside a loosely defined space. The purpose of this technique is to allow a greater degree of freedom in the creation of the image.

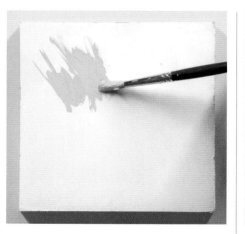 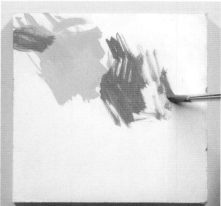

1 To begin, load the brush with slightly thinned Cadmium Yellow Light. Indicate the placement of the first flower not by drawing an outline, but by scribbling hatched marks to occupy a general space on the paper, canvas, or panel.

2 Before the paint from the previous step is dry, add a little Cadmium Orange to the mixture and indicate a loosely defined shadow area on the top of the yellow flower. Add Cadmium Red Medium to the mixture and scribble the next flower using the same technique you used in step 1.

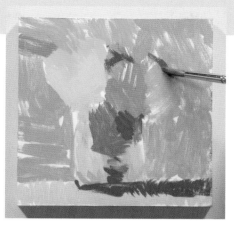

5 Mix Unbleached Titanium and a little Mars Black to create a medium-dark gray for the shadow cast by the flowers. Cover some of the shadow areas on the leaf with Cobalt Blue. Complete the painting by adding definition to a few of the flower edges.

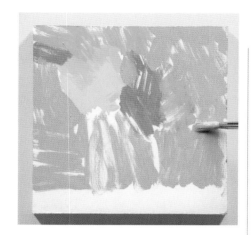

3 Add Unbleached Titanium to the mixture and indicate pink petals using the scribble technique. Add Mars Black and Titanium White to the mixture to create a warm gray. Apply this color to the background and inside the glass with similar directional strokes.

Often, when a painting employs expressive elements, it is necessary to sacrifice descriptive details for the sake of more energy and excitement in the execution of the image.

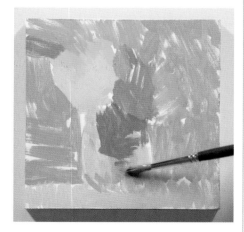

4 Add Cobalt Blue and Cadmium Yellow Light to the mixture to make a pale green to paint the leaf inside the glass. For maximum expressive effect, alter the direction of the scribbles as you proceed through the next step.

22 | Varying brushstrokes: Road and sky

Materials

- White paper, canvas, or gessoed panel
- #4 filbert brush
- Palette
- Water
- Acrylic painting medium

Color palette

- Unbleached Titanium
- Burnt Sienna
- Mars Black
- Cadmium Yellow Light
- Yellow Ochre
- Cadmium Orange
- Cobalt Blue
- Titanium White

Try these

 20
 21
 23
 26
 30
 44

A great way to add interest to your paintings is to vary the smoothness and roughness of your brushstrokes and edges. Using a paint mixture with a higher quantity of medium will result in hard, sharp edges. To achieve rough, undefined strokes, use a mixture that is mostly pigment and drag your strokes gently across the paper, canvas, or panel (this techniques is known as "drybrush"). For this exercise, alternate between rough, drybrush strokes and juicy, hard-edged marks.

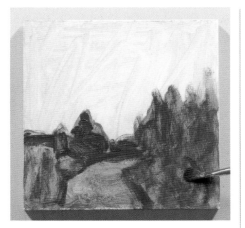

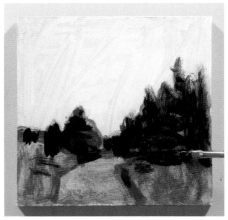

1 Begin by toning your paper, canvas, or panel with a thin layer of Unbleached Titanium. When this layer is dry, use Burnt Sienna to indicate the shape of a road and trees. Start with a thin wash for the lighter areas and progress to full-strength as you darken.

2 Mix Mars Black with a small amount of Cadmium Yellow Light to create a deep green for the trees. Paint the trees with gentle, horizontal drybrush strokes. Keep your brushstrokes very loose and allow the edges to remain rough and undefined.

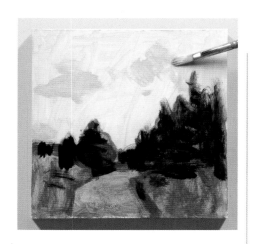

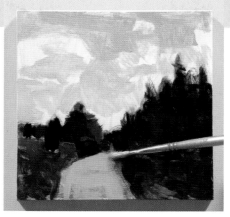

5 Paint the medium-dark greens with a loose application of Mars Black and Cadmium Yellow Light. Clean your brush thoroughly and mix Unbleached Titanium and Cadmium Orange for the road. Remember to apply in loose, rough strokes to create interesting textures.

By alternating rough and tight brushwork, you can give your painting variety and a sense of vibrancy and movement.

3 To paint the clouds, apply the grays first—using a mix of Unbleached Titanium and a little Mars Black—and then surround them with the blue of the sky. This avoids making the colors of the sky too muddled and allows you to vary the edges of the clouds.

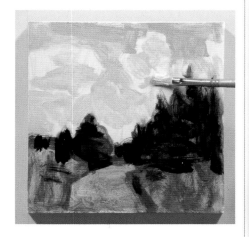

4 Next, paint the blue of the sky using a mix of Cobalt Blue and Titanium White, leaving the initial Unbleached Titanium and grays to represent the clouds. This approach may seem counterintuitive, but doing it this way allows bits of the "cloud" color to show through and creates a much more integrated sky/cloud pattern than outlining the clouds and filling them in.

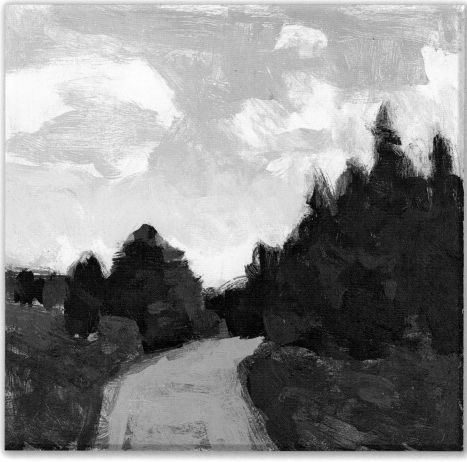

23 | Using loose strokes:
Impressionist landscape

Materials

- White paper, canvas, or gessoed panel
- #6 round brush
- #4 filbert brush
- Palette
- Water
- Acrylic painting medium

Color palette

- Cadmium Orange
- Yellow Ochre
- Cerulean Blue
- Titanium White
- Ultramarine Blue
- Burnt Sienna
- Alizarin Crimson

Try these

20

21

25

29

30

33

Creating a painting in the Impressionist style is a great way to work on loosening up. Since the subject will be painted with a collection of small, repetitive strokes, there is less need for precision and more room for interpretation. Here, you'll begin with an underpainting of Cadmium Orange and then apply green and blue over the top. Allowing specks of the warm orange to show between the strokes will balance the cool colors and unify the painting.

1 Use a thin wash of Cadmium Orange to indicate the initial placement of the basic shapes of the landscape. Notice that the shapes are arranged to suggest a feeling of depth: the shapes nearest to the viewer are larger and the shapes get smaller as they recede into the distance.

2 Fill the areas that will represent the grass and foliage with a slightly more opaque wash of Cadmium Orange. Paint the shapes that will ultimately represent the water and the sky with a thinner, more transparent wash of Cadmium Orange. Allow the paint to dry for 5 minutes.

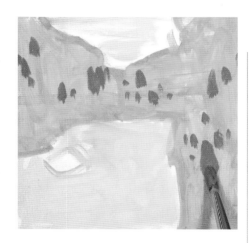

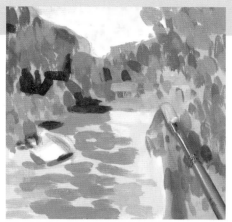

3 Mix a medium-value green using Yellow Ochre and Cerulean Blue and begin filling in the trees and grass with short, simple brushstrokes using the #6 round brush. Use vertical strokes to represent the grass and trees to contrast with the horizontal strokes you will use for the water.

5 To establish a greater sense of form, outline the shapes to the left with a mixture of Ultramarine Blue and Burnt Sienna using the #4 filbert brush. Add some neutral violet colors to the foliage to add a little color variety. Finish the painting by suggesting some rocks, using Titanium White and Cerulean Blue, and by adding subtle changes to the trees and the water.

Remember to keep your strokes distinct and clear; try to avoid moving the paint around once you've applied it. This will give your painting the signature "Impressionist" appearance.

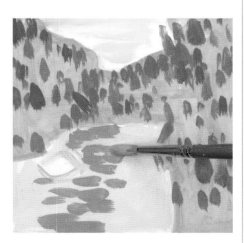

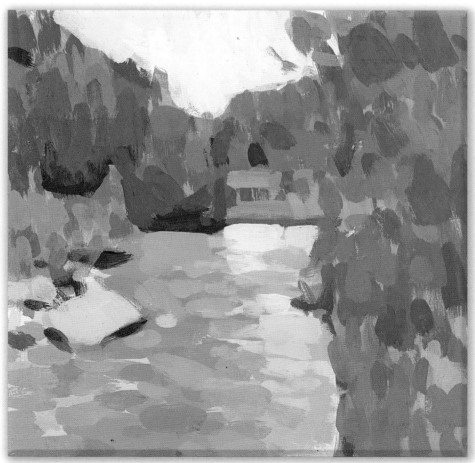

4 Continue filling in the greens, adding more Cerulean Blue for the distant trees, more Yellow Ochre for the closer trees. With a mixture of Cerulean Blue and a little Titanium White, start filling the river shape with small, horizontal brushstrokes. Remember to allow some of the dry underpainted color to show through.

24 | Redefining the brushstroke:
Drip painting

Materials

- White paper, canvas, or gessoed panel
- #8 round brush
- #8 long-bristle egbert brush
- Palette
- Water
- Acrylic pouring medium

Color palette

- Yellow Ochre
- Burnt Sienna
- Unbleached Titanium
- Mars Black
- Titanium White

Try these

Over the course of recent art history, there is a clear progression in "the evolution of the brushstroke." Beginning with the Impressionists and their signature dabs of broken color, this developed through the Fauvists and their bold, jagged brushstrokes, eventually leading to the Abstract Expressionists of the 20th century with their revolutionary techniques of applying paint. For this exercise, you will be applying paint by filling the brush with fluid color and dripping it on the canvas.

1 This is a messy process—protect your surroundings from the airborne paint. Mix a very thin combination of Yellow Ochre, water, and acrylic pouring medium. Load your brush and flick your wrist to drip paint on the surface. Repeat this step with separate layers of Burnt Sienna and Unbleached Titanium, allowing the paint to dry between each application.

2 Start to layer the drips with a variety of analogous colors (that are close to each other on the color wheel) using mixtures of Cadmium Red Medium, Cadmium Orange, and Cadmium Yellow Light. Keeping the colors analogous will help to unify the chaotic arrangement of random drips. Add a layer of gray drips made from Mars Black and Titanium White for a bit more variety.

5 Continue to build layers of colored drips until you are satisfied with your composition. Remember to use colors that are similar whenever possible to keep the painting unified. Using colors and values that have a great deal of contrast will create a chaotic, disunified result.

This project lends itself to making multiple paintings to create a series. Try it a few more times with different colors and hang the resulting paintings in a group.

3 Continue to add layers of color, allowing a few minutes between each layer for the paint to dry so it will not bleed into the previous color. Add a layer of pure Mars Black thinned with acrylic pouring medium. This medium will help the paint to adhere to the previous layers.

4 When the paint is dry, drip on some Unbleached Titanium. Experiment with different thicknesses of dripped paint by varying the speed and intensity of your hand movements.

25 | Painting with colored shapes: Rooster

Materials

- White paper, canvas, or gessoed panel
- #8 round brush
- Palette
- Water
- Acrylic painting medium

Color palette

- Yellow Ochre
- Titanium White
- Unbleached Titanium
- Mars Black
- Cadmium Orange
- Burnt Sienna
- Cadmium Red Medium

Try these

3

5

28

33

47

49

Subjects with soft edges and gradated colors are more difficult to paint in acrylics than images with distinct, hard-edged shapes. Generally speaking, birds fall into the latter category thanks to their "graphic" plumage patterns. For this project, you will be layering the basic patterns of a rooster's feathers. It is not necessary to try to paint each feather individually; in fact, it is better if you treat each part of the feather pattern as a separate shape.

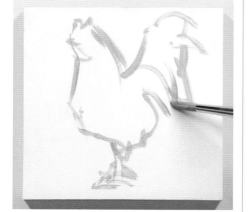

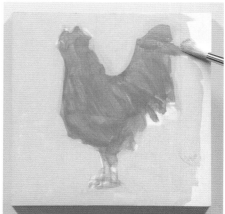

I Begin with a basic outline of a rooster in Yellow Ochre. If you need help sketching the shape, try using one of the transfer techniques described in the introduction (see pages 28–29). Fill the inside of the shape with Yellow Ochre. Allow the paint to dry before proceeding to step 2.

2 Fill in the space around the rooster with a mixture of Titanium White and Unbleached Titanium. This will allow you to clean up some of the initial sketch lines and make corrections to the basic shape of the rooster.

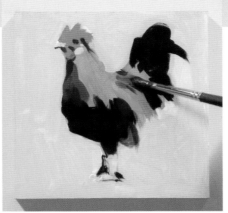

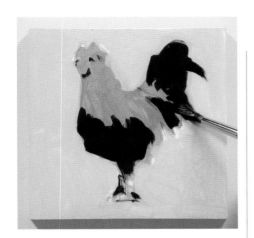

5 Use Unbleached Titanium and Titanium White to paint the beak and the white patches below the eye. Paint the shadow under the beak with Burnt Sienna. Use Cadmium Red Medium to paint the comb and the feathers near the back. Paint the background using Unbleached Titanium and loosely indicate the grass at the rooster's feet with a mixture of Yellow Ochre and a small amount of Mars Black.

Painting groups of generalized shapes rather than trying to render every individual detail will give your paintings more impact and clarity.

3 When the painting is dry to the touch, use Mars Black to paint the first set of shapes to represent all of the black feathers on the rooster. Leave a border of Yellow Ochre around the black to add some variety to the feathers. Use Mars Black to indicate the rooster's eye.

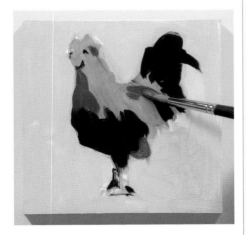

4 Use Cadmium Orange to indicate feathers on the neck and hindquarters. Add Burnt Sienna to paint the feathers under the bird's head, behind its leg, and on the back of its wing. Do your best to keep the shapes simple and hard-edged.

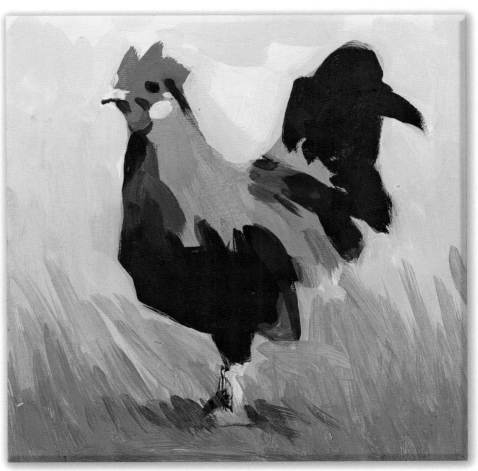

26 | Large shapes and small details: City scene

Materials

- White paper, canvas, or gessoed panel
- #10 round brush
- #8 round brush
- Palette
- Water
- Acrylic painting medium

Color palette

- Unbleached Titanium
- Mars Black
- Cadmium Yellow Light
- Cadmium Red Medium
- Titanium White

Try these

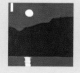 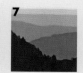

When painting a complex scene with many parts, it is tempting to try to render as much of the scene as possible in high detail. While this approach does not necessarily doom you to failure, another option would be to loosely represent the larger shapes in the scene and add a few well-placed details to finish the piece. For this project you will be painting large, simple shapes first and then adding small, tight details. It is often surprising to see how much "finish" you can achieve in a painting with just a few spots of detail.

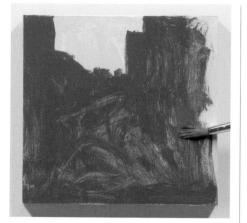 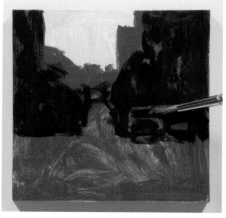

1 Using the #10 round brush, paint Unbleached Titanium over the whole surface to create a warm-toned background. This will help to balance the coolness of the grays you will be adding later. Allow to dry. Next, mix a medium-dark value gray with some Mars Black and Unbleached Titanium and loosely fill in the foreground and the silhouettes of the buildings.

2 Add more Mars Black to the mixture you used in step 1 and add a few simple elements to your painting: Loosely indicate the outline of the street as well as some trees and a car on the side of the street. There is no need to include any small details at this point; just focus on establishing the large shapes.

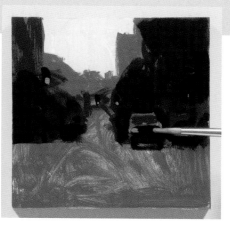

5 To complete the painting, switch to the smaller #8 round brush and Cadmium Red Light and add the red stoplights and the brake lights of the cars. Fill in the sky with a glaze of Titanium White and Unbleached Titanium and add extra definition to details in the foreground.

Contrasting broad, simple, neutral-toned shapes with small, specific saturated-color details gives a painting a pleasing variety of finished and unfinished areas.

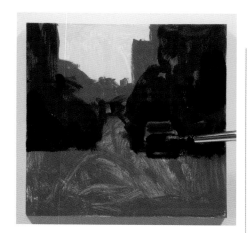

3 Using full-strength Mars Black, deepen the shadows in the foreground. You will need to darken the trees lining the street and the tires and trunk of the car. You will also need to make a few short vertical strokes to represent the stoplights (you will add the lights in step 5).

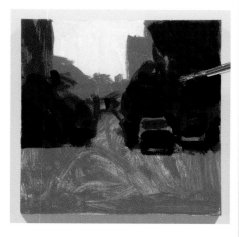

4 Next, add a small amount of Cadmium Yellow Light to the Mars Black you were using in step 3. Use this green to color the trees lining the street in the foreground. Because green is the complementary color to red (which you'll be adding in the next step), each color will make the other appear more vibrant.

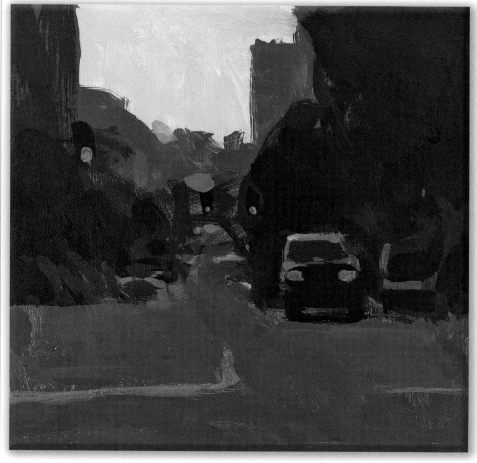

27 | Simplifying a landscape:
Snow scene

Materials

- White paper, canvas, or gessoed panel
- #10 round brush
- Palette
- Water
- Acrylic painting medium

Color palette

- Yellow Ochre
- Cadmium Yellow Light
- Cobalt Blue
- Mars Black
- Titanium White
- Unbleached Titanium

Try these

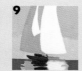 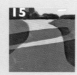 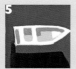

Painting an outdoor scene that contains multiple detailed parts can be a daunting task. It's helpful to simplify the many complex details found in nature into more cohesive, unified patterns. For this exercise, imagine the painting split into two distinct parts: the foreground (which is in shadow) and the middle ground (which is bathed in sunlight). You will use simplified shapes (rather than details) to represent the trees and snow.

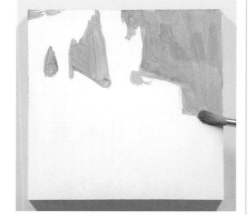

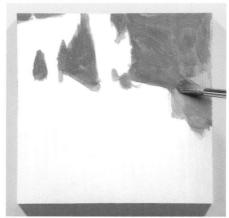

1 Using Yellow Ochre, paint a group of trees (this technique is known as "massing," which will be explained further in upcoming projects). It is helpful to divide your painting into simplified patterns as opposed to starting with details so you can get an early idea of how the composition will look.

2 When the paint is dry, mix Cadmium Yellow Light with a very small amount of Cobalt Blue to create a bright green for the foliage. Thin the mixture with acrylic painting medium and apply the glaze using directional strokes to describe the form of the trees.

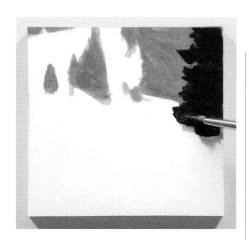

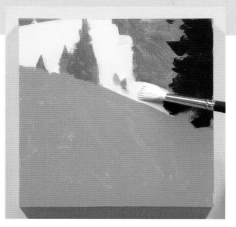

5 To complete the painting, mix a very small amount of Unbleached Titanium with Titanium White to create a warm white. Use this color to clean up any stray brushstrokes and give the illusion of bright, sun-bathed snow in the distance.

Simplifying with basic patterns will help you to create more cohesive, unified paintings.

3 When the paint from the previous step has dried to the touch, mix a deep, dark green by adding a little Cadmium Yellow Light to Mars Black. Use this color to paint the silhouette of a tree in the foreground. Because this tree is in shadow, it will add a feeling of depth and distance when compared to the trees in the light.

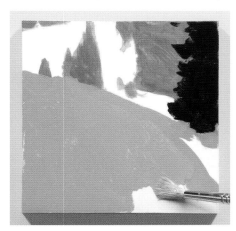

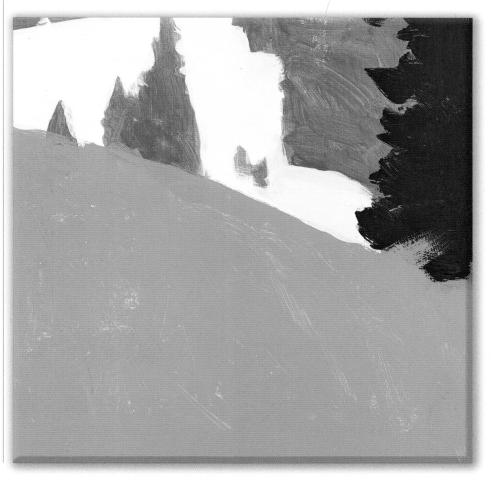

4 To separate the shadow on the snow in the foreground from the light in the distance, simply mix Cobalt Blue into a larger quantity of Titanium White and apply this color to the entire foreground. Be sure to take the blue shadow up into the silhouetted tree so they will appear to be on the same plane.

28 | Massing shapes:
Bunch of bananas

In this exercise, you will learn a technique known as "massing." This involves combining groups of small, detailed shapes into larger, more generalized shapes. If you are unsure about which shapes to combine, an easy trick is to look at your subject with half-closed eyes. This will obscure the details and help you to get a better sense of the overall shapes that make up the subject.

Materials

- White paper, canvas, or gessoed panel
- Palette
- #8 round brush
- #4 flat brush
- Water
- Acrylic painting medium

Color palette

- Cadmium Yellow Light
- Cadmium Orange
- Yellow Ochre
- Cobalt Blue
- Cerulean Blue
- Titanium White
- Dioxazine Purple
- Mars Black

Try these

 25
 26
 29
 30
 31
 50

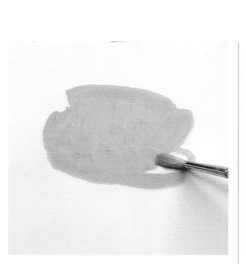

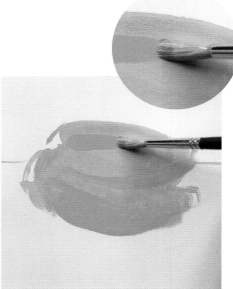

1 Using the #8 round brush and opaque Cadmium Yellow Light, paint a shape—or "mass"—that represents the whole bunch of bananas, without using any details to describe the individual fruits. Wait about 10 minutes for the paint to dry before proceeding to the next step.

2 With a mixture of Cadmium Orange and Yellow Ochre, block in the areas of shadow. In this example, the bananas are lit from directly above so the shadows will be cast on the lower portion of each fruit.

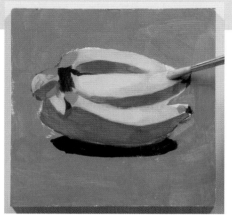

5 Add a tiny amount of Cerulean Blue to some Cadmium Yellow and apply this green color to the tips of the bananas. Using a mix of Cadmium Yellow Light and Titanium White, paint a few soft-edged highlights over the existing yellow to create the illusion of light hitting the fruit. Fill in the background with a mix of Cobalt Blue, Mars Black, and Unbleached Titanium.

Use the massing technique to join multiple objects into a more unified, cohesive whole.

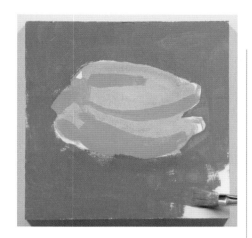

3 To create a color contrast between the bananas and the background, mix Cobalt Blue, Cerulean Blue, and a little Titanium White. Apply this mixture to the background using the #4 flat brush. Clean up any stray brushstrokes and sharpen the edges of the bananas.

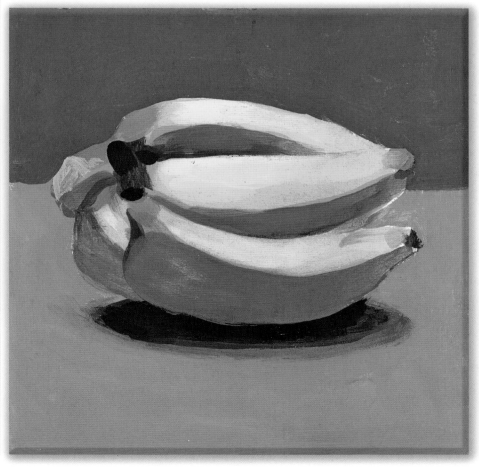

4 Mix equal amounts of Cadmium Orange and Dioxazine Purple to create a dark brown color for the stems and lower tips of the bananas. Use this color for the shadow under the bunch of bananas too. Mix a thin glaze of Yellow Ochre and Unbleached Titanium and paint over the shadowed areas of the bananas to indicate reflected light.

29 | Massing in nature: **River and trees**

Materials

- White paper, canvas, or gessoed panel
- #10 round brush
- Palette
- Water
- Acrylic painting medium

Color palette

- Yellow Ochre
- Ultramarine Blue
- Cadmium Yellow Light
- Mars Black
- Titanium White
- Cobalt Blue
- Burnt Sienna

Try these

When painting scenes from nature, the biggest challenge is often eliminating unnecessary details. All of the leaves, branches, grasses, sticks, and rocks vye for your attention. One solution is to join the parts together (also called "massing") and sprinkle a few details in strategic places. For this project, try to think of the painting as having three essential shapes: the shape representing the water; the shape representing the trees, grass, and foliage; and the shape representing the sky.

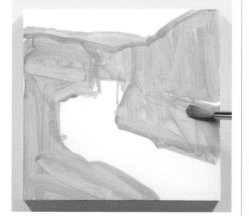

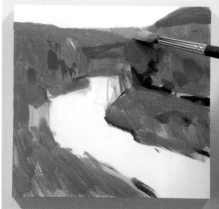

I Block in the three basic shapes on the paper, canvas, or panel. Paint all foliage, trees, and grass with a thin layer of Yellow Ochre. This will create a warm-toned underpainting to lay the cooler blues and greens over later. Allow this layer to dry for 10 minutes before proceeding to the next step.

2 Begin in the foreground with a vibrant green made of Ultramarine Blue and Cadmium Yellow Light. Add Mars Black to this mixture for the shadows under the trees and grass. As the shapes progress into the distance, add small amounts of Titanium White to the same green and apply to the far hills. Colors become paler and duller the farther away they are, so this will add to the illusion of distance.

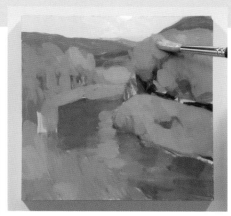

5 Complete the painting by making subtle changes to the greens in the trees and grass. To add variety, alternate between greens that have more yellow in the mixture and greens with more blue.

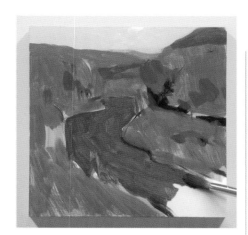

3 Use a mixture of Titanium White and Cobalt Blue to paint the sky shape. Painting the river will be a two-step process. Begin with a layer of Burnt Sienna (this will represent the bottom of the river that can be seen through the reflections). Allow this layer to dry for 10 minutes.

The task of painting the overwhelming amount of information in a landscape can be daunting. Try squinting to reduce the scene to simple, basic shapes.

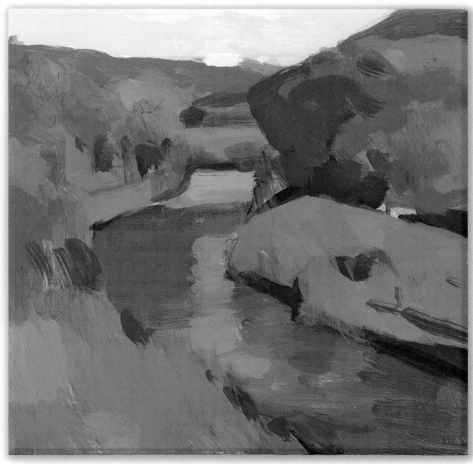

4 To render the illusion of water that is reflecting the color of the sky while still showing the river bottom, gently brush combinations of Cobalt Blue, Titanium White, and Burnt Sienna across the surface of the river. Use horizontal strokes to imitate the ripples on the surface of the water.

30 | Massing multiple objects:
Poppy field

This project requires that you combine multiple objects into one large group, or "mass." This has the effect of organizing the complexity of the group into a more cohesive, unified whole. For this exercise, try to imagine two distinct shapes: shape one is the poppies as a group; shape two is the green field surrounding them. There will be variations within each shape but, for the most part, the flowers will all use common colors and values, as will the field.

Color palette

- Cadmium Orange
- Cadmium Red Medium
- Mars Black
- Cadmium Yellow Light
- Ultramarine Blue

Try these

10

21

23

25

26

31

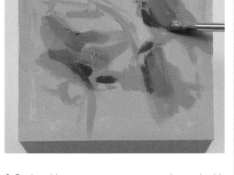

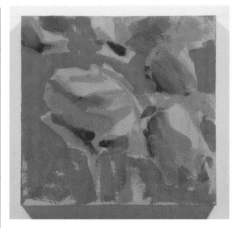

1 Begin with a paper, canvas, or panel toned with Cadmium Orange. This color will represent the lightest values of the flowers. Use Cadmium Red Medium to paint the medium values on the flowers. Apply the color in blocks so that the flower shapes form larger wholes. Deepen the shadows in a few places by adding a little Mars Black to the Cadmium Red Medium.

2 Mix Cadmium Yellow Light with a small amount of Ultramarine Blue and use this color to define the grassy areas of the field. Remember to allow the large shape representing the entire group of flowers to remain intact.

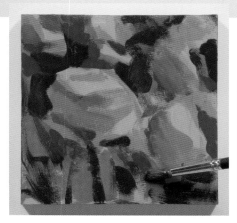

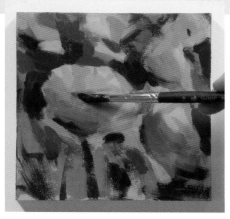

5 To complete the painting, add a mixture of Mars Black and Cadmium Red Medium to the dark areas at the center of the flowers as well as in the background field. Restate any reds, oranges, or greens to finish defining the "flower-shape" mass.

3 Deepen the colors of the field by adding Mars Black to the green mixture you used in the previous step. Use this color to further define the edges of the poppies and to increase the contrast between the flowers and the field. Green and red are complementary colors so each will make the other appear more vibrant.

When faced with painting an image of multiple objects that are similar, it is helpful to group those objects together in a large mass.

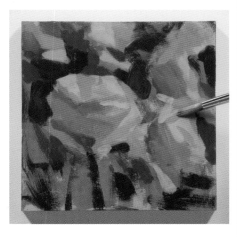

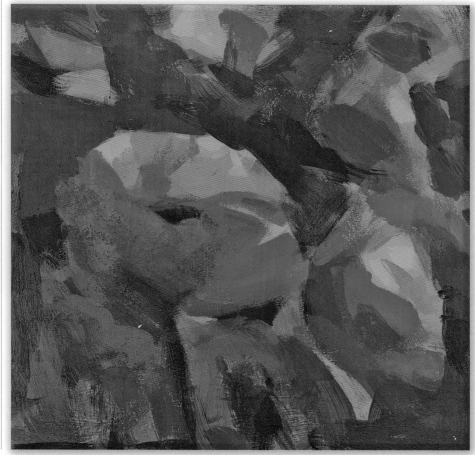

4 Restate some of the lighter colors on the petals with a mixture of Cadmium Orange and Cadmium Yellow Light. Keep in mind that the light areas of the flowers will all be essentially the same value.

31 | Creating contrast with temperature: **Sunflowers**

Materials

- White paper, canvas, or gessoed panel
- #10 round brush
- Palette
- Water
- Acrylic painting medium

When referring to color, the term "temperature" is used to describe its relative warmth or coolness. For example, orange is a "warm" color and blue is a "cool" color. These terms can also be applied to the relative temperature of a color when compared to another similar color. You may find a "warm green" and a "cool green" in the same painting. This exercise will focus on using contrasting temperatures to create dramatic effect.

Color palette

- Yellow Ochre
- Cadmium Yellow Light
- Mars Black
- Cerulean Blue
- Titanium White
- Cadmium Red Medium

Try these

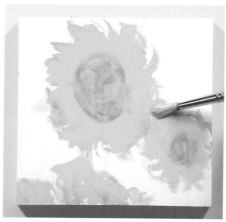

1 Begin with a loose sketch of some sunflowers using slightly thinned Yellow Ochre. Make one of the flowers large, one medium, and the other small to create variety within the shapes. Allow the flowers to overlap for a more unified composition.

2 When the paint is dry, load the brush with full-strength Cadmium Yellow Light and paint a loose indication of the petals. Drag a little of this color over the flower centers as well.

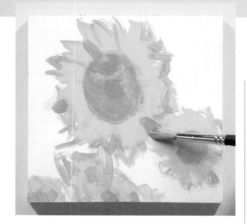

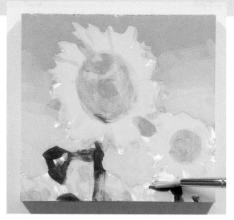

5 To complete the painting, paint a simple gradation (see project 4, pages 42–43) behind the flowers. Begin at the top with a mixture of Cerulean Blue and a little Titanium White. As you work downward, add more Titanium White to the mixture. Mix Cadmium Yellow Light and Cadmium Red Medium to paint the colors at the center of the flowers.

3 Describe the petals and center disks further with Yellow Ochre. The center of a sunflower in a painting will often become a focal point. Allow your brushwork to be loose and lively. You will have the chance to clarify any stray brushstrokes in step 5.

Juxtaposing warm against cool colors gives your paintings a sense of dramatic color contrast.

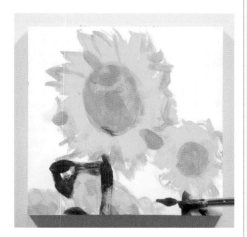

4 To make the green for the stems and leaves, mix a small amount of Mars Black into some Cadmium Yellow Light. Loosely indicate the stems.

32 | Accenting with a complementary color:
Birch trees

Materials

- White paper, canvas, or gessoed panel
- #10 round brush
- Palette
- Water
- Acrylic painting medium

Color palette

- Unbleached Titanium
- Yellow Ochre
- Phthalo Blue
- Ultramarine Blue
- Mars Black
- Dioxazine Purple
- Cadmium Orange
- Titanium White

Try these

"Analogous" refers to colors that are next to one another on the color wheel. Limiting the range of colors you use will naturally result in more unified, harmonious paintings. One problem with strictly analogous color schemes, however, is that they sometimes appear too narrow in color. An excellent way to fix this is to use a very small amount—an "accent"—of the color from the opposite side of the color wheel, called the "complement."

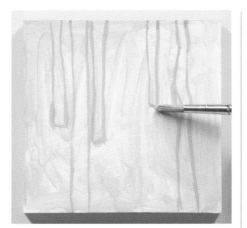

1 Begin your painting by toning the canvas, paper, or panel with a thin mixture of Unbleached Titanium. When this is dry to the touch, sketch a basic outline indicating thin trees using Yellow Ochre. Try not to make the trees too stiff or straight; allow them to be somewhat irregular.

2 To begin establishing the analogous color group, fill in the grassy areas and add details in the trees with Yellow Ochre. Strictly speaking, this color is not on the blue/green side of the color wheel, but it will help to unify those colors when you fill in the rest of the painting.

5 Add Mars Black to the mixture you used in step 4 and paint the stark shadows cast by the trees. To balance the blue/green bias of the painting, mix Dioxazine Purple with a little Cadmium Orange and use this color for the knots in the trees. Clean up any stray brushstrokes in the trees with a mixture of Titanium White and Unbleached Titanium.

3 When the paint is dry, mix the color for the grass using Yellow Ochre and Phthalo Blue. Apply this color in a semi-opaque glaze, allowing some of the Yellow Ochre to show through.

Using a limited range of colors is a great way to harmonize your paintings. Adding accents of the complementary color helps to keep your colors balanced.

4 Now create a slate-blue color for the water by adding Phthalo Blue, Ultramarine Blue, Mars Black, and Unbleached Titanium to the green from step 3. Using this green will harmonize the colors. Note that the grass and the water are rather close in color and value.

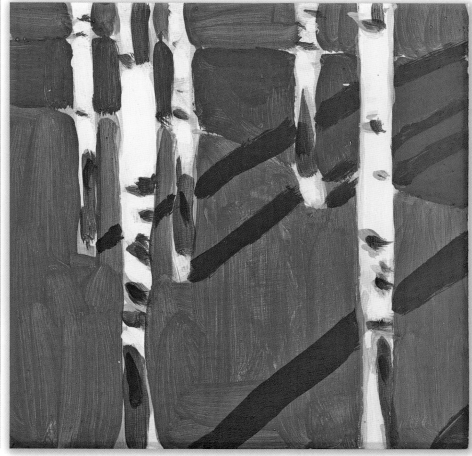

33 | Using exaggerated color:
Expressionist landscape

Materials

- White paper, canvas, or gessoed panel
- #10 round brush
- Palette
- Water
- Acrylic painting medium

Color palette

- Cadmium Red Medium
- Cobalt Blue
- Cadmium Yellow Light
- Ultramarine Blue
- Unbleached Titanium
- Yellow Ochre
- Titanium White

Artists often assume that painting a recognizable subject requires accurately copying colors directly from nature (or a photograph). Contrary to this belief, there are abundant possibilities available to the artist who is willing to experiment with the colors found in nature. Oversaturating or otherwise exaggerating the colors one sees will immediately make a painting appear more interpretive and thus more expressive. This exercise involves exaggerating the colors—as well as the shapes—found in nature.

Try these

 12
 17
 21
 23
 24
 30

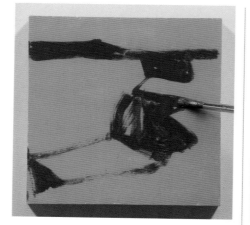

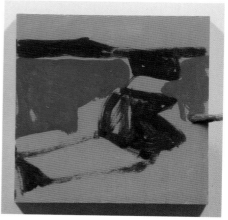

1 Begin by painting the paper, canvas, or panel with an opaque layer of Cadmium Red Medium and allow it to dry completely. Use Cobalt Blue to sketch the shapes of an abstract landscape.

2 Mix Cadmium Yellow Light with Ultramarine Blue to create a vibrant green and apply this color to the grassy areas of the painting. Use loose and lively brushstrokes. As you work through the steps, be sure to allow some of the red to show through for added boldness.

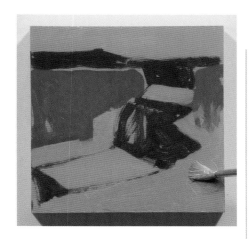

3 Mix Cadmium Yellow Light with Unbleached Titanium and a small amount of Yellow Ochre and apply this color to the shapes below those you painted in step 2. Allow some of this color to overlap the greens on the right.

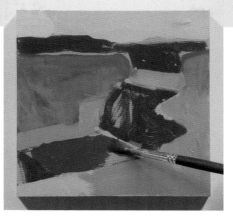

5 Paint the small patch of sky with a mixture of Cobalt Blue and Titanium White. Develop the foreground shapes with variations of red, yellow, green, and violet, mixed from the colors on your palette. Feel free to experiment with the colors by lightening, darkening, and oversaturating them.

It's often surprising how little nature's colors need to be modified to make a painting boldly expressive.

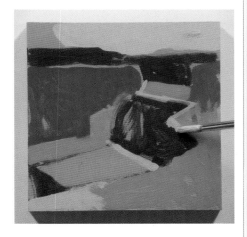

4 To create more graphic interest between the shapes, outline a few of them with Unbleached Titanium. Use this color for the cloud shape above the horizon as well. Repeating a color in this way helps to unify the upper and lower parts of the painting.

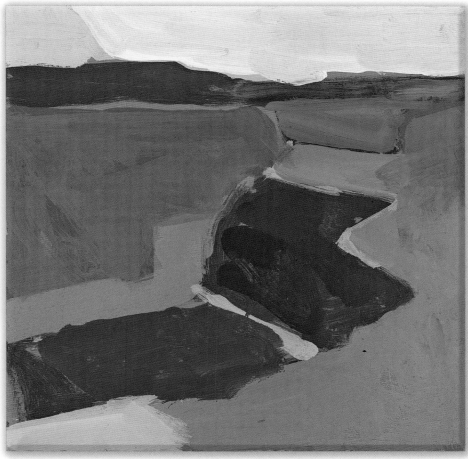

Chapter 4

Rendering surface and form

The projects in this chapter will advance your skills in the rendering of a variety of surfaces and objects. You will learn to paint the effects of glass, metal, wood, marble, paper, flesh, and more.

34 | Painting simple highlights:
Light bulb

Materials

- White paper, canvas, or gessoed panel
- #8 round brush
- Palette
- Water
- Acrylic painting medium

Color palette

- Yellow Ochre
- Unbleached Titanium
- Burnt Sienna
- Mars Black
- Titanium White

Try these

 6

 10

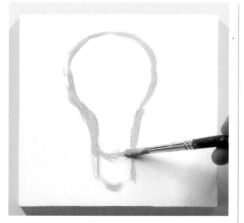 35

 40

 41

 42

Different surfaces reflect and absorb light in different ways. Highly polished surfaces will have distinct, sharp-edged highlights while soft surfaces will have smooth, soft-edged highlights (if they have any highlights at all). For this exercise, you will be rendering highlights on two different surfaces: glass and metal. You will revisit each of these surfaces in the coming projects.

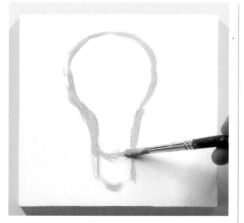

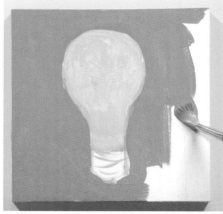

1 Paint a basic outline of a light bulb with Yellow Ochre. You may want to use one of the transfer techniques described in the introduction to ensure accuracy (see pages 28–29). Don't worry too much about painting it perfectly though, as you will be covering most of the outline with opaque paint in later steps.

2 Fill in the outline of the bulb with Unbleached Titanium but leave the metal casing at the bottom unpainted for now. Paint the area surrounding the bulb with a combination of Unbleached Titanium and Burnt Sienna. Allow to dry for 5 minutes before proceeding to step 3.

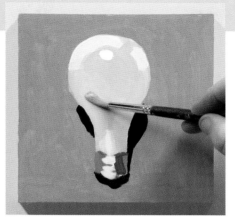

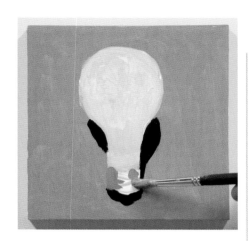

5 When the paint has dried, apply a thin, transparent glaze of Unbleached Titanium to the interior of the bulb—but do not cover the highlights. This will unify the colors and make the bulb appear to be made from a single material.

The glass used in light bulbs often is quite opaque. In the next few projects, you will be introduced to techniques for rendering translucent and transparent surfaces.

3 To show that it is resting on a surface, paint a shadow behind the light bulb using Mars Black. Mix Titanium White with a little Mars Black and paint the sides of the metal light bulb base. Leave the center of the metal base unpainted for now as you will be placing highlights there in step 5.

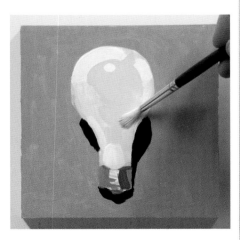

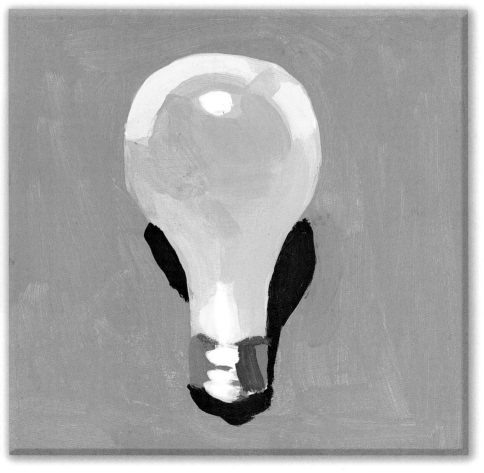

4 To paint the highlights on the bulb, add a few simple shapes along the edge and a dot near the top using Titanium White. Fill the interior of the bulb with a mixture of Unbleached Titanium and a little Mars Black. Paint a highlight on the metal base with Titanium White.

35 Rendering a transparent object:
Balloon dog

Materials

- White paper, canvas, or gessoed panel
- #8 round brush
- Palette
- Water
- Acrylic painting medium

Color palette

- Unbleached Titanium
- Cerulean Blue
- Titanium White
- Ultramarine Blue

Try these

 34
 40
 41
 42
 48
 50

Painting a balloon animal is a delightful activity not just because the subject evokes fond memories of childhood, but it's also a great way to start learning the basics. For this exercise, you won't need any of the more precise drawing skills required for a more complicated subject, and you can paint the entire balloon animal—in this case, a dog—using variations of basic ellipses and a very narrow range of colors. Remember that the object you are depicting is round and bulbous, so avoid using straight lines. Once you are finished, try this exercise again with a variety of balloon animals and colors.

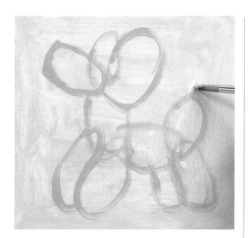

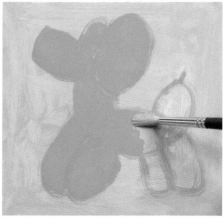

1 After toning your paper, canvas, or panel with a thin wash of Unbleached Titanium, sketch the basic shapes of the balloon animal, using ovals and ellipses in a mixture of Cerulean Blue and Unbleached Titanium.

2 Mix a little Cerulean Blue into a larger amount of Titanium White and use this mixture to fill in the elliptical shapes. Leave some of the original sketch showing through so you can keep track of where the edges of the balloon shapes are located—you'll need to see them when adding definition in step 3.

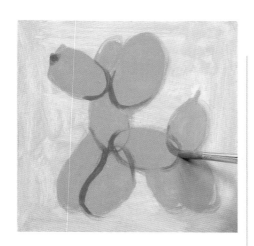

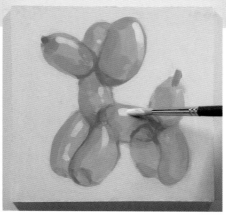

5 Mix Cerulean Blue, Titanium White, and acrylic painting medium into a very thin, very transparent glaze. Paint it all over the balloon dog to unify the colors and values. Fill in the background with a mixture of Titanium White and Unbleached Titanium. Finally, add highlights in Titanium White.

3 Add some Ultramarine Blue to the mixture you used in step 2. Use this darker color to restore all the outlines in your original sketch. Outlining the inner shapes as well as the outer silhouette will help to create the illusion that the balloon shapes are transparent.

When you have finished, try producing a series of paintings of balloon animals and hanging them as a group.

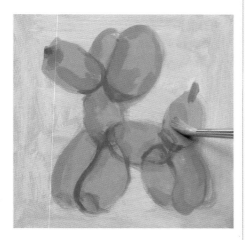

4 Mix Titanium White and Cerulean Blue to create a color that is darker than the base color you used to fill in the shapes, but lighter than the outlines. Use this to indicate shadows on the left and bottom of the balloon shapes. Let the painting dry for at least 30 minutes.

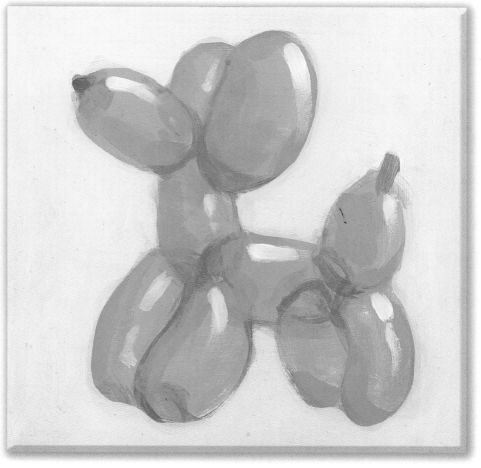

36 | Warm light, cool shadow:
Gift box

Materials

- White paper, canvas, or gessoed panel
- #8 round brush
- #4 filbert brush
- Palette
- Water
- Acrylic painting medium

Color palette

- Cadmium Red Medium
- Unbleached Titanium
- Alizarin Crimson
- Mars Black
- Titanium White
- Cadmium Orange

Try these

In most cases, when painting objects, the color temperature of the light is warm, as it originates from a light bulb or the sun, and the color temperature of the shadow is cool, reflecting the surroundings. This exercise is similar to project 8 (pages 50–51), however, here you will be adding color to the box, a ribbon, and a cast shadow. You will notice that the gift box is essentially just a simple cube with a bow tied around it. In this painting, the light is coming from the right.

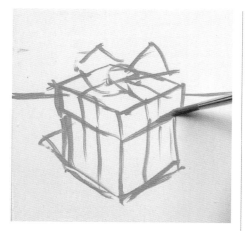

1 Using the #8 round brush and a thin wash of Cadmium Red Medium, sketch the basic outline of the gift box. Add the ribbon and bow, and draw a line behind the box to indicate the back of the table on which the box is sitting.

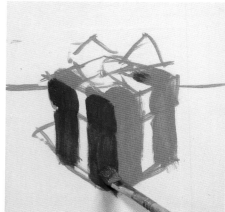

2 With the #4 filbert brush, fill in the entire outline of the box with a mixture of Cadmium Red Medium and a very small amount of Unbleached Titanium. Do not fill in the bow at this stage. Wait 10 minutes for the paint to dry, then fill in the left side of the box with a mixture of Cadmium Red Medium and Alizarin Crimson.

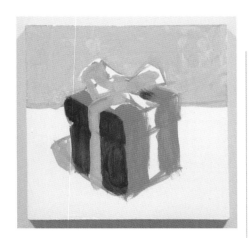

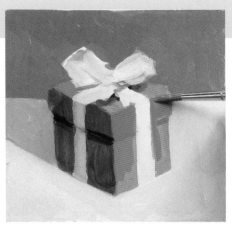

5 Use a mixture of Titanium White and Mars Black to paint the cast shadow on the tabletop. Apply a small line of this color under the lid to indicate a shadow. Apply a thin glaze of Cadmium Red Medium and Cadmium Orange mixed with acrylic painting medium to unify the red portions of the gift box.

3 Mix a very small amount of Mars Black into a larger amount of Titanium White to create a light gray. Use this color and the #8 round brush to fill in the shadow areas of the bow, as well as the background above the table.

Using warm light and cool shadows together will create a pleasing sense of contrast in your paintings.

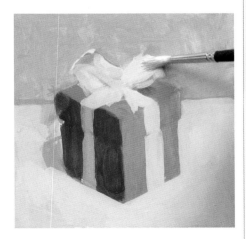

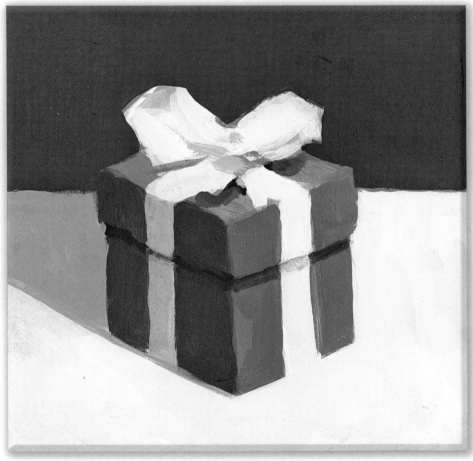

4 Using Titanium White mixed with a small amount of Unbleached Titanium, fill in the white areas of the bow. Color the right side of the box with a mixture of Cadmium Red Medium and Unbleached Titanium. With each layer of paint, make necessary corrections to the initial drawing.

37 | Rendering intricate details:
Clothespin

Materials

- White paper, canvas, or gessoed panel
- #8 round brush
- #6 round brush
- Palette
- Water
- Acrylic painting medium

Color palette

- Yellow Ochre
- Unbleached Titanium
- Burnt Sienna
- Ultramarine Blue
- Cadmium Yellow Light
- Mars Black

Try these

Creating a painting of an everyday object like a clothespin may seem an easy task. However, its narrow silhouette and intricate parts make it a challenging subject. If you're having trouble accurately sketching the clothespin directly on your surface, try using one of the transfer techniques explained in the introduction (see pages 28–29). Try to be as precise as possible when you draw the lines and fill in the shapes; precision early on will help you to avoid the need for too many corrections.

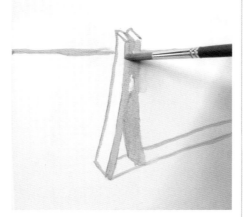

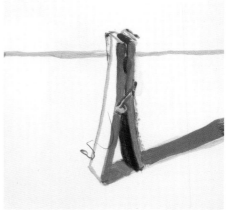

1 Using the #8 round brush and a thin mixture of Yellow Ochre and a very small amount of Unbleached Titanium, sketch the basic outline of the clothespin in the center of your paper, canvas, or panel. Add a horizontal line to represent the back of the table.

2 Combine Burnt Sienna with a small amount of Ultramarine Blue to create a dark brown. Use this color to paint the center line and inner sides of the clothespin. Next, combine Yellow Ochre, Unbleached Titanium, and a small amount of Burnt Sienna. Use this color for the shadow on the front of the clothespin and on the table.

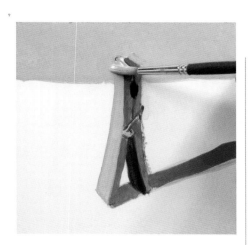

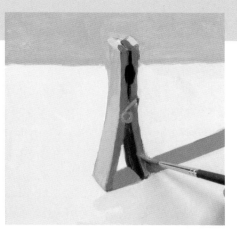

5 Fill in the shadow side of the clothespin with a mixture of Burnt Sienna, Yellow Ochre, and Unbleached Titanium using the #6 round brush. To create the color for the cast shadow on the tabletop, mix Unbleached Titanium with a little Mars Black.

Your home is likely full of humble objects that would make great subjects for paintings like this one. Explore your junk drawers and closets for more unconventional subjects.

3 To paint the left side of the clothespin that is facing the light, use a mixture of Cadmium Yellow Light, Yellow Ochre, and Unbleached Titanium. Fill in the background with this mixture as well. If a brushstroke strays outside your outline, you will have a chance to clean it up in the next step.

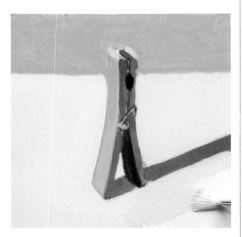

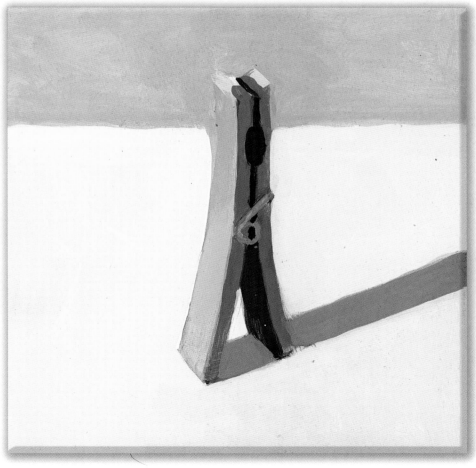

4 Mix Titanium White with a very small amount of Unbleached Titanium. Apply this color over the tabletop, and to the tips of the clothespin prongs to suggest highlights. Clean up any stray brushstrokes with this color.

38 | Painting wood: Chair

Materials

- White paper, canvas, or gessoed panel
- #4 filbert brush
- #4 flat brush
- Pencil
- Palette
- Water
- Acrylic painting medium

Color palette

- Yellow Ochre
- Mars Black
- Unbleached Titanium
- Burnt Sienna
- Titanium White

Try these

Painting an object with surface variations, such as wood or rocks, can be rather complicated if you try to render the texture after the object has been painted. A more effective approach is to paint the textured surface first, then the surrounding space, leaving the texturing intact. For this project you will begin with rough, textural brushstrokes to accentuate the grain of the wood on the chair and proceed to "carve out" the background surrounding the chair.

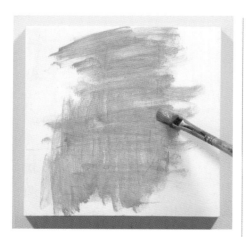

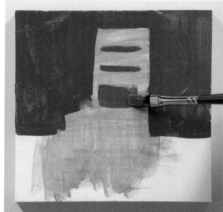

1 First, sketch a very light indication of the placement of the chair in pencil (see Transferring your image, pages 28–29). You'll need this as a guide to know where the edges of the shape are. Using the #4 filbert brush and Yellow Ochre, paint textural strokes to suggest the wood grain. Be sure to keep the strokes rough.

2 Allow the paint from step 1 to dry for 5 minutes. With the #4 flat brush, apply a mixture of Mars Black and Unbleached Titanium to the background "negative shapes" between the slats in the back of the chair. A flat brush is ideal for this type of application because it creates very sharp, squared edges.

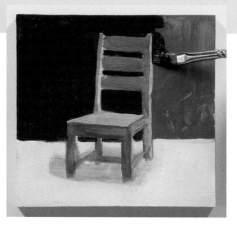

5 Using Mars Black, paint the background shapes one last time with the flat brush and clean up any loose or messy brushwork from the previous steps. Darken the shadow under the chair slightly by glazing a thin mixture of Unbleached Titanium and a little Mars Black.

In most cases, it is much easier to paint textured surfaces in acrylics when you start with the texture and then carve out the negative space surrounding the object, leaving the texture intact.

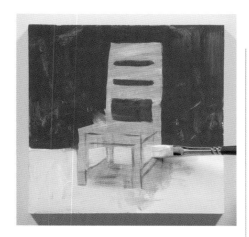

3 Using the flat brush and Titanium White, paint the foreground and the negative shapes between the legs and crossbars of the chair. Be careful not to paint over the chair itself in order to keep the textural brushstrokes intact.

4 Using the filbert brush and a thin glaze of Burnt Sienna, paint the shadows on the chair. As you apply this color, allow your brushstrokes to remain rough to maintain the illusion of wood grain. Be sure to leave the thin strips of Yellow Ochre showing through to suggest the light planes of the chair.

39 | Creating texture with layering:
Old boat

Materials

- White paper, canvas, or gessoed panel
- #10 bristle round brush
- Palette
- Water
- Acrylic painting medium

Color palette

- Unbleached Titanium
- Yellow Ochre
- Burnt Sienna
- Cobalt Blue
- Mars Black
- Light Blue Permanent
- Titanium White

Try these

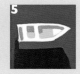
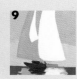

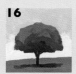

Old, weathered objects, with their accumulation of dents, pits, and scratches, are fascinating subjects for painting. You can simulate this effect by layering textures in acrylic paint. For this project, you will paint an old, sun-beaten boat on a beach. You will begin with the rust-colored underpainting and layer the colors of the boat slowly, allowing the underlying rust colors to show through for a weathered patina.

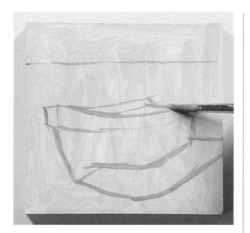

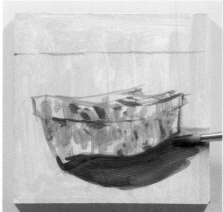

1 Begin by toning your canvas or panel with a thin layer of Unbleached Titanium. When this layer has dried, sketch the outline of a boat in the center of the paper, canvas, or panel, using Yellow Ochre. Draw a line to indicate the horizon. If you need help with sketching the boat, use one of the transfer techniques described on pages 28–29.

2 Lay the initial layer of rust and damaged wood on the boat by scumbling a random texture using Yellow Ochre. Follow this with some more random texturing using Burnt Sienna. Use Burnt Sienna to create a warm undertone for the shadow on the sand next to the boat.

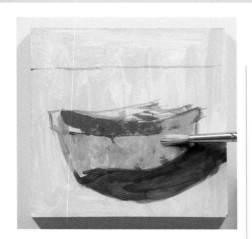

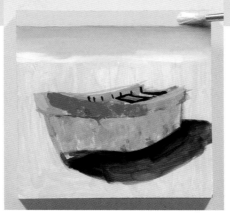

5 Paint the ocean using the same technique described in project 4 (pages 42–43). Start with Light Blue Permanent along the horizon, and add Titanium White as you get closer to the beach. For the sky, use a color similar to the gray you used on the side of the boat. Paint the sand with Unbleached Titanium.

3 Begin to apply layers of drybrushed paint to the surface of the boat. Use Cobalt Blue for the rim of the boat and a mixture of Unbleached Titanium, Cobalt Blue, and Mars Black for the side of the boat. Be sure to build the color slowly and allow the initial layer of rust/ weathering to show through.

Textured, weathered surfaces are easily achieved by layering rough, dry brushstrokes.

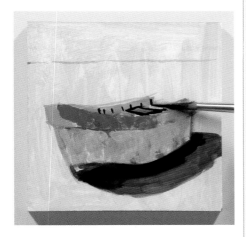

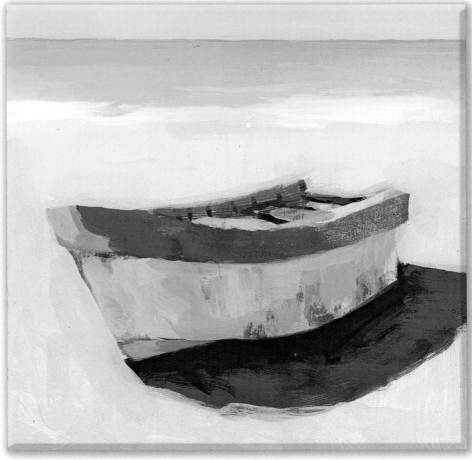

4 Add some details to the painting by applying a mixture of Light Blue Permanent and Titanium White to the strip of wood that is in the sun on top of the boat. Using Mars Black, trace the shadow under the boat, then add some details to the seats inside the boat.

40 | Reflections on metal:
Tin cup and cherry

Materials

- White paper, canvas, or gessoed panel
- #4 filbert brush
- Palette
- Water
- Acrylic painting medium

Color palette

- Unbleached Titanium
- Cadmium Orange
- Titanium White
- Mars Black
- Cadmium Red Medium

Try these

 11 34 35

 41 42 50

Learning to render reflective materials, such as metal, glass, and plastic, is always effort well spent. There is something enchanting about seeing a two-dimensional flat surface that convincingly conveys the illusion of a reflection. Bear in mind that a reflective surface will mirror its surroundings. In most cases, it will reflect the surface it is sitting on, as well as any nearby objects. To reinforce this effect, you will be painting a clear reflection of a cherry resting next to a cup.

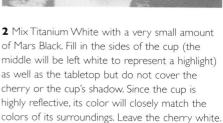

1 Sketch the outline of the cup and cherry as well as the cup's shadow and the back edge of the table with a thin mixture of Unbleached Titanium and Cadmium Orange. Remember that the cup is a simple cylinder and the cherry will be a simple sphere. Do your best to keep the cup symmetrical. Indicate the shadow behind the cup and the edge of the table at the back.

2 Mix Titanium White with a very small amount of Mars Black. Fill in the sides of the cup (the middle will be left white to represent a highlight) as well as the tabletop but do not cover the cherry or the cup's shadow. Since the cup is highly reflective, its color will closely match the colors of its surroundings. Leave the cherry white.

5 Using a mixture of Mars Black and Unbleached Titanium, fill in the background and the shadows cast by the cup and cherry. With a medium-value gray made from Titanium White, Unbleached Titanium, and Mars Black, fill in the tabletop. Finish the cherry by glazing it with a thin layer of Cadmium Red Medium.

3 Fill in the cherry with Cadmium Red Medium. Add a small patch of red to the cup to represent the reflection of the cherry. Next, mix Mars Black with a little Unbleached Titanium to create a dark gray. Use this color to fill in the background and the shadows cast by the cup and cherry.

When painting reflections on a surface, it is essential that you maintain consistency between the colors of the object and its surroundings.

4 Mix some Titanium White and Cadmium Red Medium to create a pinkish color and apply to the right side of the cherry. Using pure Titanium White, add a small, sharp highlight to the cherry. Begin to develop the cup with various shades of medium and light gray made from Titanium White and Mars Black.

41 | Reflections on a colored surface: **Blue cup**

Materials

- White paper, canvas, or gessoed panel
- #4 filbert brush
- #4 round brush
- Palette
- Water
- Acrylic painting medium

Color palette

- Ultramarine Blue
- Unbleached Titanium
- Cerulean Blue
- Cobalt Blue
- Cadmium Orange
- Cadmium Red Medium
- Mars Black
- Titanium White

Try these

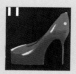

For this project, you will be painting a cup made of opaque colored glass. When rendering highly reflective surfaces, it's important to keep in mind that a smooth, polished surface will have reflections that are sharp and distinct. Glass, hard plastic, and polished metal will reflect their surroundings very clearly—rather like reflections in a mirror—so pay special attention to how closely the reflections in your painting resemble the actual shapes they are reflecting.

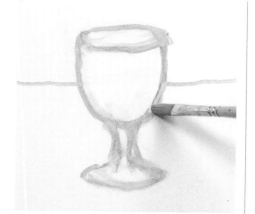 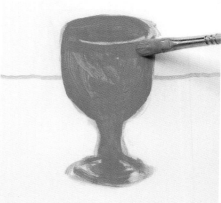

1 Using a thin wash of Ultramarine Blue mixed with Unbleached Titanium, paint a rough outline of your cup with the #4 filbert brush. Make sure the cup is centered and symmetrical, but don't worry about making the edges perfect as you'll be covering the outline with opaque paint later.

2 Fill in the outline of the cup with a mixture of Cerulean Blue and Unbleached Titanium. Now is the time to make any corrections to the symmetry of your cup. Leave a small amount of the initial outline showing to indicate a highlight on the top of the cup.

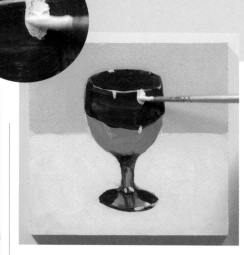

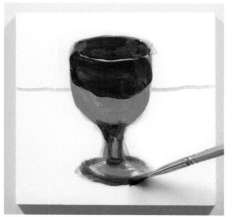

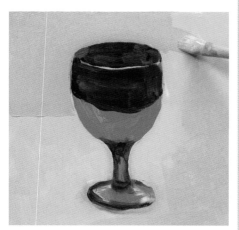

5 Apply a mixture of Ultramarine Blue and a little Cadmium Red Medium to the inside of the cup as well as the sides and base. This warm color will help to integrate the blue colors of the cup into the warm colors of the background. To finish, paint a cast shadow using a mixture of Unbleached Titanium, Cerulean Blue, and a little Mars Black. Clean up the reflections on the cup by adding pure Titanium White to the highlights using a #4 round brush.

When painting reflections on a smooth surface, pay close attention to the shapes surrounding the object.

3 Once the paint is dry, mix Ultramarine Blue with a small amount of Cobalt Blue and use to fill in the darker reflections. Trace the outline of the cup's stem as well as the ellipse at the base of the cup. Wait a few minutes for the paint to dry.

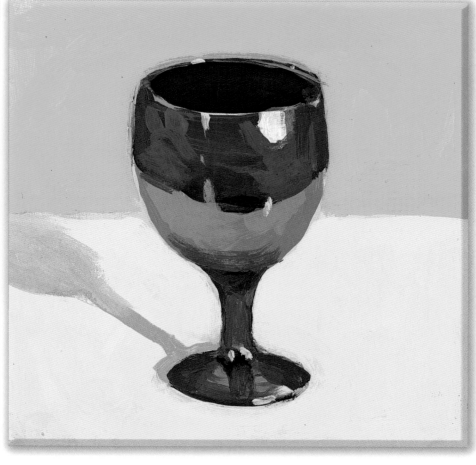

4 Cover the entire background with an opaque layer of Unbleached Titanium, leaving a faint outline of the edge of the tabletop as a guide. This is the perfect time to clean up any stray brushstrokes that remain from the initial rough sketch. When the paint is dry, combine a small amount of Cadmium Orange with Unbleached Titanium and fill in the upper half of the background.

42 | Painting a transparent surface: **Glass jar**

Try these

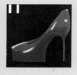

It is easy to become overwhelmed when painting transparent objects because you are rendering not just the object itself, but also anything you can see on the other side of it. In this exercise, you will paint an indication of what is behind the glass jar first (a simple red backdrop), followed by the jar, and finally the reflections and highlights. Rather than trying to render every detail, it helps to squint and look for simple, generalized shapes.

1 Start by using a thin wash of Cadmium Red Medium as a background color to indicate the placement and size of the jar. Drawing a centerline first will make it easier to keep everything symmetrical. Don't worry too much about getting things exactly right at this stage as you'll be able to make corrections later.

2 Mix a thin wash of Titanium White and a little Mars Black. Use this to begin filling in the interior of the jar as well as the gray shadow cast by the jar. Keep your brushwork loose and lively at this stage; try to leave any tight, detailed painting for the end of the project.

5 Mix a variety of grays using Titanium White, Mars Black, and hints of Cadmium Red Medium to finish the jar. Clean up the background and tabletop. Paint the highlights with Titanium White.

Remember to squint to find simple, basic shapes rather than rendering the details. You'll find that using this approach will make your paintings appear livelier and less labored.

3 Use opaque Cadmium Red Light to define the jar by "carving out" its edges (see project 11, pages 56–57). Paint the edge as accurately as possible so that you won't need to correct it later.

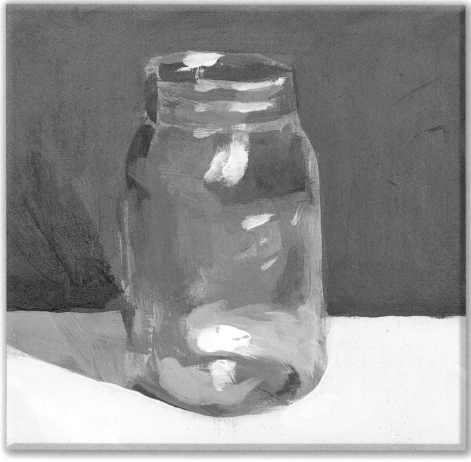

4 Now it's time to paint the background color showing through the glass jar. Mix a very small amount of the gray from step 2 into the red from step 3. Use this mixture to paint any red that you see through the jar. Add a touch of Alizarin Crimson to the shadow on the background behind the jar.

43 | Rendering multiple planes:
Crumpled paper

One of the many challenges in rendering a multi-faceted object is to ensure that the surface changes are visible, yet the object is not fragmented by too much contrast between the individual planes. To achieve a harmonious surface, keep the adjacent values as close to one another as possible (for instance, do not paint a very dark plane next to a very light plane). Visualize the light source; the planes that are facing the light will be brightest and the values will become gradually darker as the planes turn away from the light.

Try these

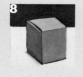
8

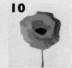
10

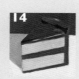
14

20

28

48

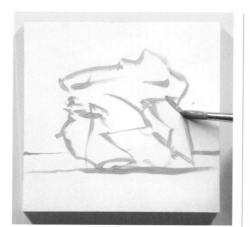

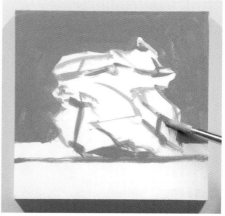

1 Using the #10 round brush and Yellow Ochre, sketch in the basic outline of the crumpled paper. Indicate the placement of the main folds first. Using a warm color for the underpainting will help to balance the cooler grays you will use in the coming steps.

2 Mix a medium-value gray using Mars Black, Titanium White, and Unbleached Titanium (which will warm the color of the gray slightly). Using the round brush, restate the main folds inside the paper with this color and lay in the initial layer for the background. Allow the paint to dry for 5 minutes.

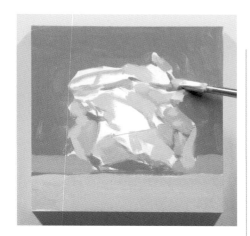

3 Add a little Titanium White and Unbleached Titanium to the medium gray to create a medium-light gray. Begin to model the form by filling in the separate planes using the round brush, and applying a single stroke for each plane. Try half closing your eyes while you work to check for cohesiveness in the overall form.

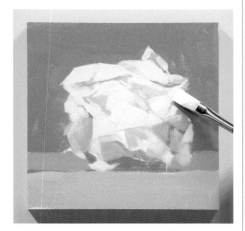

4 Use pure Titanium White and the #4 flat brush to indicate the lightest planes of the crumpled paper. Using this brush will create crisp, hard-edged strokes that are ideal for defining the facets and folds of the paper.

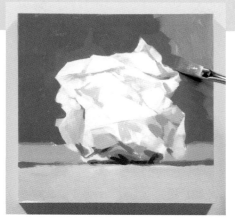

5 Mix a dark gray and, using the flat brush, apply it to the creases at the bottom of the crumpled paper. Add a little Unbleached Titanium to this mixture to create a medium-dark gray. Use it to define the folds further, as well as the horizontal shadow under the paper. Use this same color to paint the background too.

Rendering an object with numerous surface changes can be a daunting task. Just remember that each plane has a relationship to the light source and gets lighter or darker depending on how directly it faces the light.

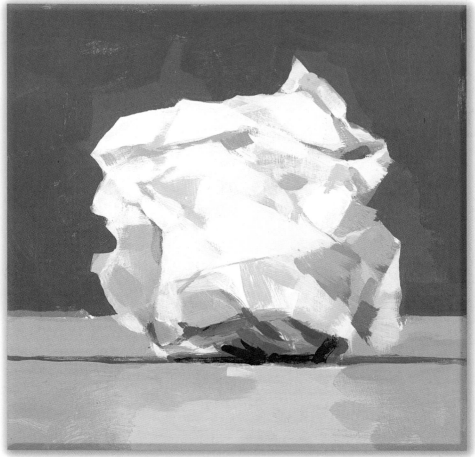

44 | Advanced landscape painting:
Mountain scene

Materials

- White paper, canvas, or gessoed panel
- #10 round brush
- #4 flat brush
- Palette
- Water
- Acrylic painting medium

Color palette

- Yellow Ochre
- Cadmium Yellow Light
- Mars Black
- Unbleached Titanium
- Dioxazine Purple
- Cadmium Orange
- Titanium White
- Cobalt Blue

Try these

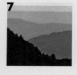 7

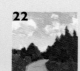 22

 27

 29

 32

 33

The sense of awe of sublime beauty we feel when viewing a majestic alpine landscape is nearly universal. Throughout history, artists have sought to convey this feeling in their paintings. The constraint of working on a small canvas means you will need to employ a few painterly tricks to suggest the vastness of such a scene in such a tiny space. By juxtaposing saturated color and detailed elements in the foreground with gray, simplified shapes in the distance, you can create a sense of vast, boundless space.

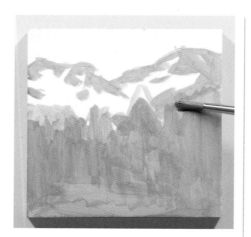

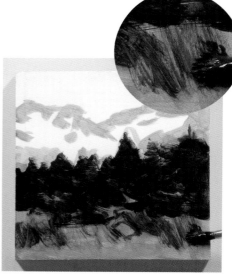

1 Begin by arranging the composition with a warm-toned underpainting in Yellow Ochre using the #10 round brush. As you have learned in previous exercises, it is helpful to begin an outdoor scene with warm tones to balance the cool greens and blues we see in nature.

2 Mix a little Cadmium Yellow Light into some Mars Black to create the dark green base color for the trees. Use directional strokes to define the form of the trees. Allow the bristles on your brush to fan out a little as you indicate the foreground grasses using drybrush strokes.

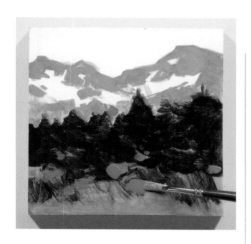

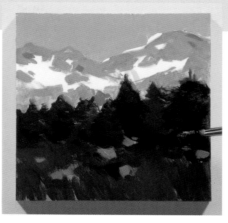

5 Make a rich green with Mars Black and Cadmium Yellow Light and fill in the grasses and trees using the #10 round brush. Use Mars Black for the shadows in the trees and near the foreground rocks. Finish the painting by cleaning up the snow patterns with Titanium White.

By separating the image into richly colored foreground, neutral distance, and blue sky you can create the illusion of grandeur and space.

3 For the distant granite peaks, start with Unbleached Titanium and add very small amounts of Mars Black, Dioxazine Purple, and Cadmium Orange until you arrive at a warm, pale gray-violet. Use the #4 flat brush to fill in the precise patterns around the snow. Add a few rocks to the foreground with this color too.

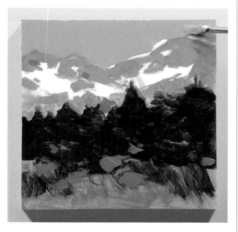

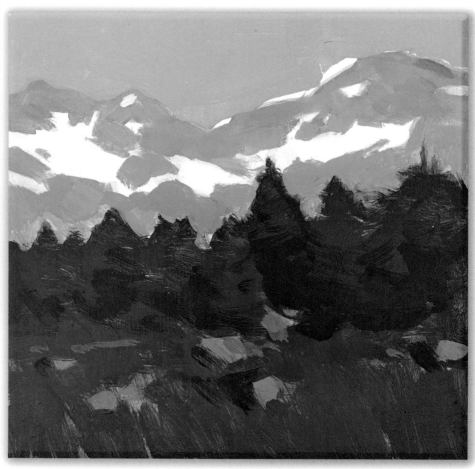

4 Due to the higher elevation in a mountain landscape, the sky is often a very vibrant blue. Mix Titanium White with Cobalt Blue and apply this color to the sky using the #4 flat brush. Clean up any rough edges left over from the sketch you did in step 1.

45 | Painting a complex scene:
Weathered townscape

Materials

- White paper, canvas, or gessoed panel
- #6 round brush
- #4 flat brush
- Palette
- Water
- Acrylic painting medium

Color palette

- Titanium White
- Mars Black
- Cadmium Orange
- Cadmium Red Medium
- Unbleached Titanium
- Burnt Sienna

Try these

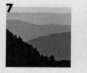
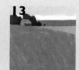
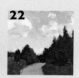

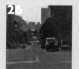

Simplifying a complex image into a cohesive whole requires the use of a few design strategies: Limiting the range of values, limiting the range of colors, and eliminating unnecessary details. For this project, you will be painting an aerial view of a bustling street in a quaint town. The variety of visual information, including figures, windows, and rooftops, will need to be unified. Try to exaggerate similarities of color, value, and shape rather than articulate the differences between the parts.

1 Tone your canvas with a medium-value gray mixture of Titanium White and Mars Black. Beginning with a toned canvas will help to unify the values from the start. When this layer has dried, indicate the outlines of the buildings with a slightly darker gray using a #6 round brush.

2 Add Mars Black to the mixture and use this mix to refine the architecture of the buildings and suggest the simple silhouettes of figures on the street. Make the strokes on the buildings bold and thick, as they will form the underpainting for the patina being applied to the buildings. Allow this layer to dry.

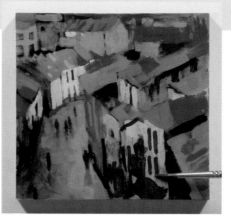

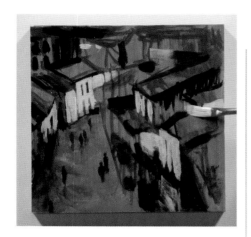

3 Apply a layer of pure Titanium White to the faces of the buildings using a #4 flat brush. This brush is ideally suited to "carving out" the precise geometric shapes surrounding windows and doorways.

5 To complete the painting, add essential details like windows and overhangs to the buildings. To make the street appear wet, paint around the figures with Unbleached Titanium mixed with a very small amount of Mars Black.

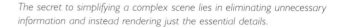

The secret to simplifying a complex scene lies in eliminating unnecessary information and instead rendering just the essential details.

4 To add some color to the scene, alternate between mixing Cadmium Orange and Cadmium Red Medium with Unbleached Titanium and a little Burnt Sienna and apply these colors to the rooftops of the buildings. Use light pressure to apply the paint and allow some of the underlying color to show through to give the sense of a weathered surface.

46 | Advanced contour painting: Elephant

Materials

- White paper, canvas, or gessoed panel
- #8 round brush
- Palette
- Water
- Acrylic painting medium

Color palette

- Yellow Ochre
- Burnt Sienna
- Unbleached Titanium
- Mars Black
- Cobalt Blue
- Cadmium Yellow Light
- Ultramarine Blue
- Titanium White

Try these

 19
 20
 25

 39
 47
 49

A useful technique for suggesting form is to use contour strokes that "bend" to describe the shape of an object. For this project, you will be painting the textured, wrinkled skin of an African elephant. As you work, keep in mind that the strokes should curve when describing roundness and straighten out when describing a flat surface. Pay special attention to the direction of your brushstrokes on the trunk, ear, and torso of the elephant.

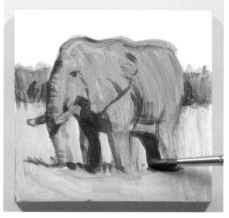

1 Begin by painting the silhouetted form of an elephant and some surrounding foliage using Yellow Ochre thinned with painting medium. As you are painting the torso of the elephant, use contour strokes to add roundness to the shape. Allow this layer to dry for 5 minutes before proceeding to the next step.

2 Using Burnt Sienna, define the dark shadows and wrinkles of the elephant. Use contour strokes to suggest form on the trunk, ear, and torso. Also indicate the trees in the distance at this time. The warm colors from this underpainting will help to balance the cool grays, blues, and greens you will add in the following steps.

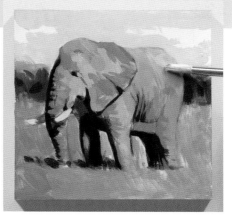

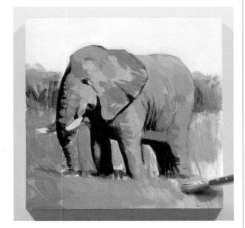

3 Begin rendering the elephant's skin with various medium-light value grays, made by mixing Unbleached Titanium with Mars Black. You can make subtle modifications to the temperature (warmth or coolness) of the grays by adding small amounts of Burnt Sienna or Yellow Ochre to the Unbleached Titanium/Mars Black mixture.

5 Add a little Mars Black and Ultramarine Blue to the green you used in step 4 to paint shadows on the distant trees. Paint the sky with Titanium White and a small amount of Cobalt Blue. Use this same color for the highlights on the elephant's rump. Continue to develop the skin of the elephant by applying subtle variations of warm and cool grays.

To create a convincing illusion of a three-dimensional object on a flat surface, describe changes in form with contour strokes.

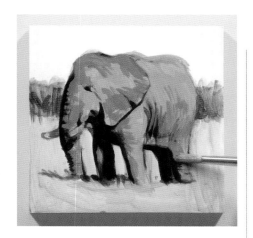

4 Paint the grass and trees with a mixture of Cobalt Blue and Cadmium Yellow Light. Add small amounts of Yellow Ochre and Unbleached Titanium to this mixture to create variety within the greens. Use vertical strokes in the foreground to suggest blades of grass.

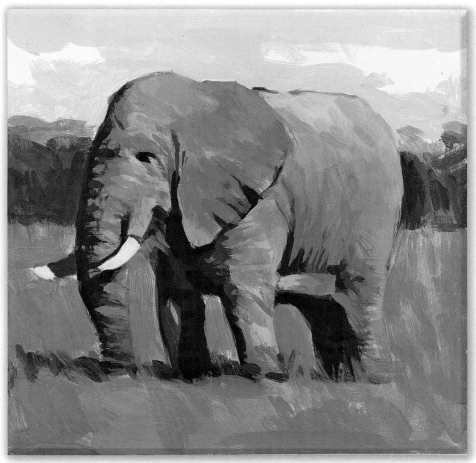

47 | Advanced light and shadow:
Cat in sunlight

Materials

- White paper, canvas, or gessoed panel
- #4 filbert brush
- #8 round brush
- #6 round brush
- Palette
- Water
- Acrylic painting medium

Color palette

- Cadmium Yellow Light
- Cadmium Orange
- Yellow Ochre
- Cadmium Red Medium
- Burnt Sienna
- Unbleached Titanium
- Titanium White
- Ultramarine Blue
- Mars Black

Try these

 7
 27
 44
 46
 48
 49

For this project, you will be painting a rather difficult subject: a cat whose body is half in light and half in shadow. The most convincing way to convey a sense of light and shadow is to keep the values consistent within the "family" they belong to (either light or shadow). This means that the darkest value in the light area will be lighter than the lightest value in the dark area and vice versa.

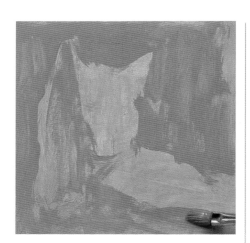

1 Begin by toning the paper, canvas, or panel with a thin mixture of Cadmium Yellow Light, Cadmium Orange, and Yellow Ochre. This will be the base color for the light area of the cat's fur. Using a mixture of Cadmium Red Medium and Cadmium Orange, fill in the background surrounding the cat, as well as the shadow area of the cat with the #4 filbert brush.

2 Using a mixture of Burnt Sienna and a little Cadmium Red Medium, sketch the basic details of the cat's features (eyes, nose, mouth) as well as the shadow in the ear and the shadow below the cat's chin and on its body using a #8 round brush. Use this color to fill in the background surrounding the cat as well.

5 Add some Burnt Sienna and a very small amount of Mars Black to the color you were using to paint the light on the fur. Use a #6 round brush to apply this color to the darker parts of the larger shadowed area (under the cat's neck, on its chest, etc.). Glaze a final layer of Burnt Sienna and Mars Black over the background to create dramatic contrast.

3 With the #6 round brush, apply a mixture of Unbleached Titanium and Titanium White to the lighter fur on the cat's mouth and eyes. Use this color to indicate the cat's whiskers as well. Mix Burnt Sienna and Ultramarine Blue and use this to trace the outline of the cat and to fill in the background using the #4 filbert brush.

The principle used here to create a convincing sense of light and shadow can be applied to any subject matter.

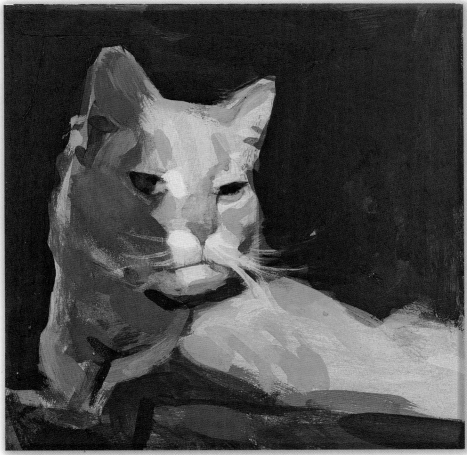

4 To paint the shadow on the cat's fur, combine Yellow Ochre, Burnt Sienna, Unbleached Titanium, and a little Ultramarine Blue (the blue will cool the temperature of the color) and apply with a #6 round brush. Remember to keep this value darker than anything in the light area. Using a mixture of Cadmium Yellow Light and Yellow Ochre, paint some tonal variations onto the light part of the fur.

48 | Grisaille painting:
Classical statue

Materials

- White paper, canvas, or gessoed panel
- #6 round brush
- Palette
- Water
- Acrylic painting medium

Color palette

- Unbleached Titanium
- Mars Black
- Titanium White

Try these

6

10

34

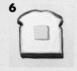
35

43

49

Grisaille painting involves glazing multiple layers of thin, transparent gray paint over one another until subtle gradations emerge. Traditionally, a grisaille painting would be used as an underpainting, which would later be glazed with color. Often, however, the colorless painting is appreciated for its austere beauty. For this exercise, the different shades of gray will not be pre-mixed on the palette. Instead, a middle value will be established and then modified by glazing layers of white or dark gray.

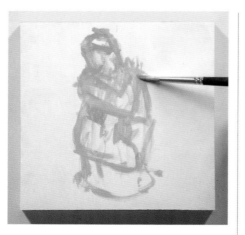

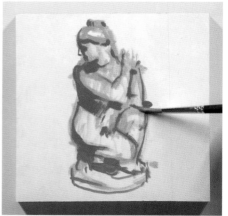

1 Begin by loosely indicating the placement of the statue in the center of your canvas using a thin mixture of Unbleached Titanium and a very small amount of Mars Black. Focus on establishing the large, generalized shapes rather than the details.

2 Add a small amount of Mars Black to your mixture and use this medium-dark gray to define the features and anatomy of the statue by painting the shadow with this color. It is not necessary to be perfectly precise at this stage, but do your best to accurately place the anatomy.

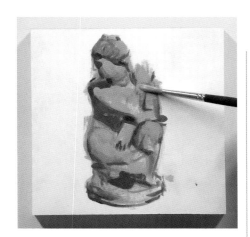

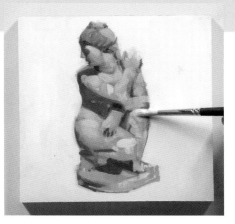

5 Continue to model the form of the statue by adding thin layers of nearly transparent Titanium White. To reestablish any shadow tones, glaze with thin layers of dark-value gray. Clean up the boundary of the statue with layers of pure Titanium White.

3 When the paint from step 2 has dried, apply a semi-transparent layer of medium-value gray to all of the parts of the statue that are not in shadow. As you progress, you will glaze layers of transparent white over this "base" tone. Allow the paint to dry before proceeding to the next step.

Continue to develop the subtle shades of gray until you are satisfied with the result.

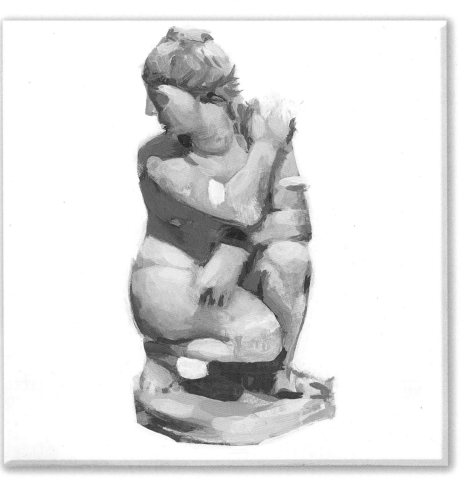

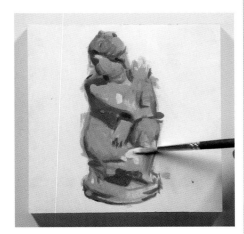

4 Begin glazing thin layers of Titanium White over the gray tone to develop the sense that light is hitting the statue. You will need to allow each layer to dry before adding the next layer. Pay special attention to the subtle effect of light this technique renders.

49 | Portrait in the classical style:
Bearded man

Materials

- White paper, canvas, or gessoed panel
- #10 round brush
- Palette
- Water
- Acrylic painting medium

Color palette

- Yellow Ochre
- Burnt Sienna
- Mars Black
- Unbleached Titanium
- Titanium White

Try these

 20
 34
 43

 46
 47
 48

Before the 19th century, the selection of colors available to the painter was rather limited. They essentially consisted of earth tones (Venetian Red, Yellow Ochre, Umbers, and Siennas) and a few vibrant blues and greens, which were very expensive. Because the artists of the time had access only to this limited palette, there is a common color-cast to all of the works from this period. For this exercise, you will be painting a portrait in the classical style, using a limited palette similar to that used by the Old Masters.

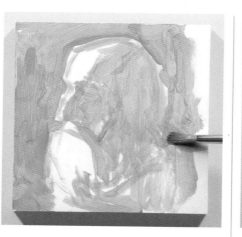

I Using Yellow Ochre, sketch the shadow areas of the man's face and the background. If you're having trouble drawing an accurate face, you may want to use one of the transfer techniques explained in the introduction (see pages 28–29). Wait a few minutes for this layer to dry.

2 Deepen the shadows and background with Burnt Sienna. Be sure to leave a little hint of the Yellow Ochre from step1 showing through, as this will add a warm glow to the light on the man's forehead, nose, and beard. Also leave a small bit showing through for the hair on the back of the head.

5 To finish, reestablish the lightest highlights on the forehead, nose, and beard with a mixture of Titanium White and Unbleached Titanium. Fill in the darkest darks one last time to create dramatic contrast between the values of the man's head.

3 Continue to develop the shadows by mixing Mars Black into the Burnt Sienna until you have established the darkest areas—nostril, lip, ear, and hair as well as the dark background. Allow some Burnt Sienna to show through to keep the overall tone of the painting warm.

This exercise demonstrates an effect called "Chiaroscuro" that was used by many of the Old Masters, including Caravaggio and Rembrandt. It involved creating dramatic contrasts of light and shadow.

4 Make any necessary adjustments to the placement of the man's features by applying Burnt Sienna and Mars Black alternately. Mix Unbleached Titanium with Mars Black to add bits of gray for the hair, beard, and eyebrows. Be patient with this step as it may take time to get the features just right.

50 | Painting elaborate detail:
Pile of candy

Materials

- White paper, canvas, or gessoed panel
- #6 round brush
- #4 round brush
- Palette
- Water
- Acrylic painting medium

Color palette

- Unbleached Titanium
- Yellow Ochre
- Cadmium Yellow Light
- Cerulean Blue
- Cadmium Red Medium
- Titanium White
- Mars Black

Try these

34

35

40

41

42

43

Nearly every project in this book has been rooted in the idea of simplicity. For this painting, however, you will be rendering a pile of wrapped hard candies in elaborate detail. The approach of progressing from simplified, generalized shapes to specific details will remain the same, but here we will take the "detail" stage of the painting further. Work slowly and methodically to avoid becoming overwhelmed by the details.

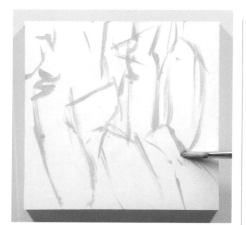

1 Loosely indicate the placement of the individual pieces of candy using a mixture of Unbleached Titanium and Yellow Ochre using a #6 round brush. If you are uncomfortable doing this freehand, use one of the transfer techniques described in the introduction (see pages 28–29).

2 Begin to establish the different colors of the candies with the #6 round brush using Cadmium Yellow Light, Cerulean Blue, Unbleached Titanium, and Cadmium Red Medium. Be sure to leave some white of the paper, canvas, or panel showing to indicate the brightest highlights on the candy wrappers. The color of the background will be shades of red, so anything that is not a piece of candy will be this color, painted using Cadmium Red Medium and Mars Black.

5 Render the twisted ends at the top and bottom of the wrappers with a warm gray color made from Unbleached Titanium and Mars Black. Look closely for any adjacent colors reflecting in the wrappers as well. Remember that any reflective surface will reflect all of its surroundings.

3 For each piece of candy there will be three primary parts: one, the color of the candy (yellow, blue, green, beige, or red); two, the tint of that color in the light; three, the crisp highlight on the plastic wrapper. As you work, try to keep these three parts distinct, i.e., don't use the pure white to render any part of the candy, only the highlight on the wrapper.

Acrylic paint is ideal for rendering subjects with hard edges. You can achieve a level of realism similar to that of a photograph if you are willing to invest the time and effort.

4 Restate the bright highlights on the candy wrappers with pure Titanium White using the #4 round brush. Because the clear plastic is highly reflective the edges of the highlight shapes should be very sharp. It may be necessary to paint over these shapes two or three times to get pure, opaque white shapes.

Glossary

Acrylic 1. A polymer resin (type of plastic) derived from petrochemicals that takes many forms, including "Perspex" sheets and "woolly" sweaters. 2. A type of water-soluble paint where pigments are suspended in an acrylic polymer resin binder, which gives the paint workability and adhesion. It dries to a hard, durable, waterproof plastic film.

Alla prima A painting made all in one go, without underpainting.

Canvas 1. A textile, which may be cotton, linen, hemp, sacking, muslin, or sailcloth, that is stretched over a frame to make a surface to paint on. 2. Any surface to which paint is applied: textile, wood, board. 3. The painting as a work in progress.

Chroma Chromatic color, colorful, made of color. Describes the intensity of a hue, and the saturation of pigment.

Complementaries Colors opposite each other on the color wheel. Placed next to each other, each has maximum intensity; mixed together, they cancel each other out.

Composition The arrangement of all the structural elements within a painting, including positive and negative shapes, horizon lines and diagonals, highlights and shadows, and color patterns.

Cool colors The blue/green/violet side of the color wheel. They appear to recede toward the back of the picture plane.

Dyad, Triad, Tetrad Color schemes built from two, three, or four colors equally spaced around the wheel.

Glaze 1. Transparent color thinly overlaid on another color, modifying its hue or giving it more depth. 2. An acrylic mixing medium that adds transparency and spreading ability to paints; can be matte or gloss.

Granulation Particles of pigment separating in over-diluted paint; a grainy effect.

Grisaille An underpainting in gray tones that establishes the structure and values of a painting.

Hot/warm colors The red/orange/yellow side of the color wheel. They appear to advance toward the foreground.

Hue 1. A particular color. 2. The name of a color.

Imprimatura A first, dilute coat of paint over the primer to "break the ice" of a too brilliant, unsympathetic white surface.

Key A high-key color scheme is bright, hot, saturated; a low-key scheme is more neutral.

Knock back To mix tiny amounts of the complementary into a color to quieten it.

Local color The actual hues on the surface of an object, perhaps reflected off other objects nearby.

Maquette Developed sketch used as a "blueprint" for an artwork.

Medium (plural: mediums) 1. A binder or vehicle for pigment; a substance that modifies the handling properties of paint. 2. (plural: media) The broad type of drawing or painting material, such as oils or acrylic.

Negative space The spaces in a painting between, around, or beyond the objects. These areas are part of the picture plane and also have to be painted, so make them shapely.

Opaque The opposite of transparent, fully opaque paint will obliterate what is underneath it.

Optical Effects that happen within the viewer's eye.

Palette 1. An artist's selection of colors. 2. The object on which the paints are laid out ready for work. 3. A surface on which paints are mixed together with a palette knife.

Pictorial color The artist's choice of colors to interpret the actual colors of objects; not necessarily "lifelike."

Picture plane The two-dimensional surface that is the painting itself, regardless of pictorial illusions.

Pigment Dry, ground, and powdered color that is mixed into a medium such as acrylic polymer resin to make a chromatic paint. There are thousands of natural and synthetic pigments available, which all behave differently.

Plein air French term for painting outdoors; alfresco in Italian.

Primary colors Yellow, red, and blue—the colors that can't be made by mixing others.

Retarder An acrylic mixing medium formulated to slow down drying times.

Saturation The purity and strength of a color. Paint as it comes from the tube is at maximum saturation; once other hues are added, saturation decreases.

Secondary colors Green, orange, and violet—made by mixing two primaries.

Shade 1. Darker value of a hue to which some "black" has been added. 2. Any variation on a basic hue.

Staining power A pigment's ability to transfer color.

Tertiary colors 1. The six colors between primaries and secondaries on the wheel, named thus: yellow-green, yellow-orange, etc. 2. "Browns" (russet, citrine, and olive) made by mixing all three primaries in different proportions.

Tint A light value of a color, made by adding a little of the hue to white.

Tone See Value. May refer to the lighter half or the whole range of values.

Value How light or dark a color is, relative to its surroundings.

Viscosity Relative fluidity or thickness of the paint. Low is runny, high is sticky.

Index

Credits

For Tiffany, Ella, and Sam.

The process of writing and illustrating the projects in this book has been an exhilarating (and at times, exasperating) experience. The fact that you are reading it now demands that I give thanks to a group of artists, students, teachers, and publishing professionals who have helped to finalize this book.

First of all, I am grateful for the expert supervision I've received from the art and editorial team at Quarto: Moira Clinch, Kate Kirby, Caroline Guest, and Victoria Lyle, who helped me to navigate a great deal of unfamiliar terrain and bring this book to completion.

Thanks also to the many inspiring teachers and mentors I've been blessed with over the years: Bernie Lucero, Orlando Mestas, Lynn Kircher, Paul Leon Ramsey, Quang Ho, Dave Hickey, and to fellow artists John Harrell and Kelly Berger for bringing this project to me.

Lastly, a heartfelt thank you to my students—in particular the members of my Monday afternoon painting class—for your indispensable feedback and for your endless curiosity and effort, which have been a constant source of inspiration.